W9-CER-089

DATE DUE

JUL 3 1 2001	APR 1 3 2009
DEC 1 5 2004	
APR 2 4 2006	

SARGEN DERNIST

The Library Store #47-0107

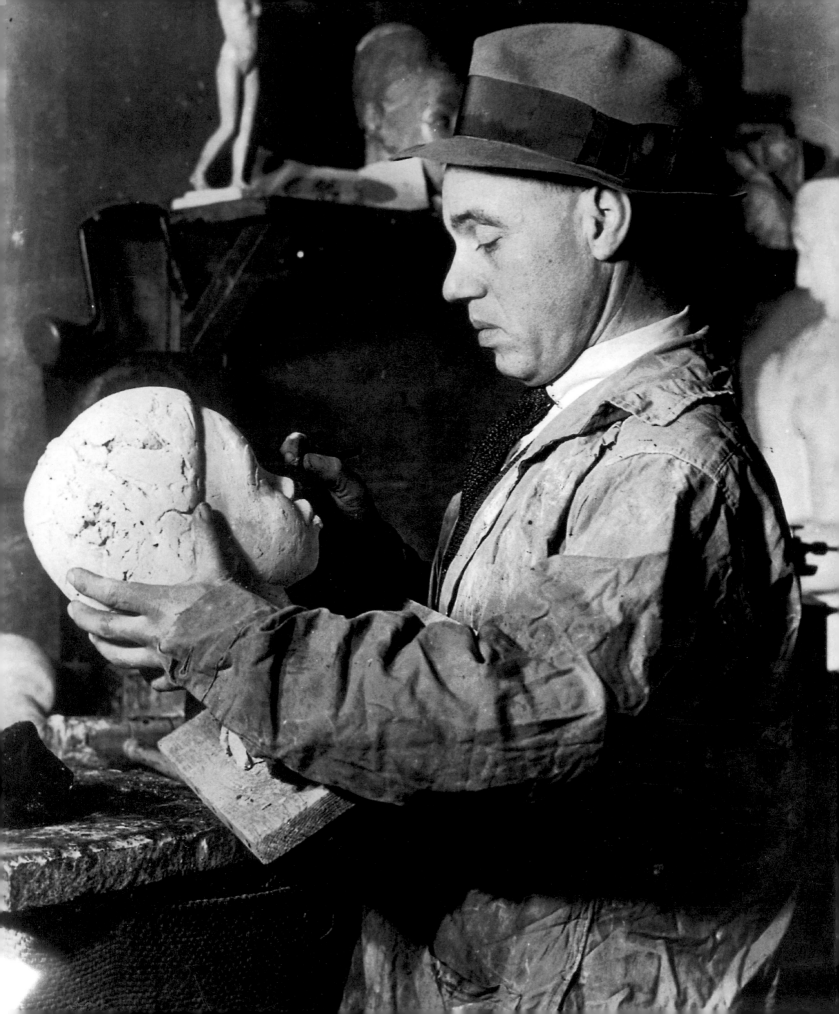

Sargent Johnson African American Modernist

Lizzetta LeFalle-Collins and Judith Wilson

San Francisco Museum of Modern Art

This catalogue is published on the occasion of the exhibition *Sargent Johnson: African-American Modernist*, organized by Lizzetta LeFalle-Collins and on view at the San Francisco Museum of Modern Art from March 13 to July 7, 1998.

Sargent Johnson: African-American Modernist is supported by a grant from the National Endowment for the Arts, a Federal agency.

Library of Congress Cataloging-in-Publication Data

LeFalle-Collins, Lizzetta.
 Sargent Johnson: African-American Modernist / Lizzetta LeFalle-Collins and Judith Wilson.
 p. cm.
 Catalogue of an exhibition held at the San Francisco Museum of Modern Art.
 Includes bibliographical references.
 ISBN 0-918471-43-5 (pbk.)
 1. Johnson, Sargent, 1888–1967—Exhibitions.
2. Afro-Americans in art—Exhibitions. I. Johnson, Sargent, 1888–1967. II. Wilson, Judith. III. San Francisco Museum of Modern Art. IV. Title.
NB237.J544A4 1998
759.13—dc21 97-28680
 CIP

Photography Credits
Photo by Ian Reeves: cover; figs. 2, 4, 7–8; and pls. 1, 8, 11, 13, 16, 19–20, 22–32, 34–39.

Frontispiece and figs. 3 and 5: National Archives; fig. 6: © Dirk Bakker, The Detroit Institute of Arts; figs. 12–13: photo by Manu Sassoonian; fig. 14: photo © 1997 Whitney Museum of American Art; pls. 2, 5, 9–10, 14: photo by Ben Blackwell; pl. 4: photo courtesy of The Newark Museum/Art Resource, New York; pl. 6: Scott Wolff Photography; pl. 21: photo by Steven Oliver.

Cover: *Forever Free* (detail), 1933 (PL. 8; Cat No. 8)

Frontispiece: *Sargent Johnson in his studio*, n.d.

Publication Manager: Kara Kirk
Editor: Fronia W. Simpson
Designer: Terril Neely
Publication Assistant: Alexandra Chappell

Printed and bound in Hong Kong

Contents

Foreword and Acknowledgments

The first two of nine sculptural works by Sargent Johnson to enter the permanent collection of the San Francisco Museum of Modern Art—*Mask* (1933) and *Head of a Negro Woman* (ca. 1935)—were gifts of Albert M. Bender in 1935, the year the Museum was founded. Bender was the Museum's most important benefactor in its early years, responsible for the acquisition of more than eleven hundred works in a wide range of media. Like many works from the Bender Collection at SFMOMA, the works by Sargent Johnson reflect the distinctive nature of visual culture in the San Francisco Bay Area at the time and embody the various forces of modernism and regionalism, nationalism and internationalism at play here through the first half of the twentieth century.

This first comprehensive survey of Johnson's career is, indeed, intended to demonstrate the artist's successful assimilation of three vital traditions: the New Negro movement and the Harlem Renaissance of the 1920s; the forms and tenets of European modernism, which first reached San Francisco through the Panama-Pacific International Exposition of 1915; and the eclectic cultural activity of the Bay Area at midcentury, from Diego Rivera's mural painting to the predominance of abstraction at the California School of Fine Arts in the 1940s. In part because of the essentially pluralistic character of the Bay Area, Johnson was able to draw from these divergent sources and create a style that is both readily identifiable and that evolved throughout his lifetime. In turn, Johnson emerged as the first African-American artist in California to achieve national acclaim through traveling exhibitions hosted by the Harmon Foundation in the 1930s and 1940s and, more recently, through exhibitions of the Harlem Renaissance in which his work is almost inevitably included.

Johnson's great masterpiece, *Forever Free* (1933), is a keystone of SFMOMA's permanent collection and has been on near continuous view in the Museum's galleries in its new building since it opened in January 1995. We are proud and delighted to have the opportunity to present this outstanding work, together with others in our holdings, in full context as part of this retrospective.

For bringing us this concept, and for her dedicated and thoughtful work on the exhibition's organization, we are indebted to guest curator Lizzetta LeFalle-Collins. There is no scholar today more equipped for the task, and we deeply appreciate her collaboration with SFMOMA over the past few years. Ms. LeFalle-Collins was assisted in the curatorial endeavor by Janet C. Bishop, SFMOMA's Andrew W. Mellon Foundation associate curator of painting and sculpture, who has herself studied Johnson in depth as part of our permanent collection presentations.

This publication, which accompanies the exhibition, benefits from an excellent essay by Judith Wilson, assistant professor of the history of art and of African and African-American studies at Yale University, and we thank her for her participation. Gwendolyn Shaw, a doctoral student at Stanford University who has worked with SFMOMA on several projects over the years, com-

piled the chronology, bibliography, and exhibition history. The publication was astutely organized by the Museum's director of publications and graphic design, Kara Kirk, and by Alexandra Chappell, publications assistant. Its handsome design was executed by Terril Neely, senior designer at SFMOMA, and it received the careful attention of editor Fronia W. Simpson.

Much as a project of this nature is enhanced by the knowledge and perspective of a guest curator, it often requires added efforts on the part of in-house staff. Special mention is due to Curatorial Assistant Suzanne Feld, who contributed greatly to the implementation and success of the project. We also appreciate the efforts of Olga Charyshyn, associate registrar; Tina Garfinkel, head registrar; Gary Garrels, Elise S. Haas chief curator and curator of painting and sculpture; Gail Indvik, coordinator of public education programs; Douglas Kerr, museum technician; Deborah Lawrence, curatorial assistant for the Education Department; Barbara Levine, exhibitions manager; Eduardo Pineda, coordinator of school and youth programs; Kent Roberts, installation manager; Peter Samis, program manager for interactive educational technologies and associate curator of education; J. William Shank, chief conservator; Jill Sterrett, conservator; Marcelene Trujillo, exhibitions assistant; and John Weber, Leanne and George Roberts curator of education and public programs.

On behalf of Lizzetta LeFalle-Collins, I would like to thank Melvin Holmes, who was extremely helpful in locating many of Johnson's works; Evangeline J. Montgomery, Dr. and Mrs. Jack Gordon, Dr. and Mrs. Edwin Gordon, and the late John Frederick, for their help in reconstructing Johnson's biography; and Dr. Cécile Whiting, for comments on an early draft of her manuscript. And, finally, Ms. LeFalle-Collins gives special thanks to her husband and sons for their patience during the six years of this project.

We especially appreciate the generosity of the many lenders to this exhibition, some of whom have had their treasured Sargent Johnson works in their homes for decades; only for this major exhibition have they released them for public view. It is a tribute to the artist that these works have become so central a part of the lives of their owners.

The exhibition and publication received the early support of the National Endowment for the Arts and is a fine example of the agency's support of under recognized artists of diverse backgrounds who have had a substantial impact on our nation's heritage.

Sargent Johnson lived in the San Francisco Bay Area for more than five decades. His work forms an important part of the Bay Area's artistic legacy, and it can be seen in sites from the Maritime Museum at Aquatic Park to George Washington High School. It finds its place alongside work by other great artists of the region, and even heralds characteristic work of the Bay Area by later generations, such as the California ceramicists and artists who have explored the intersection of black heritage and California culture. It is certainly appropriate that SFMOMA originate this exhibition of an artist whose work is so much a part of its own history.

Lori Fogarty
Deputy Director of Curatorial Affairs

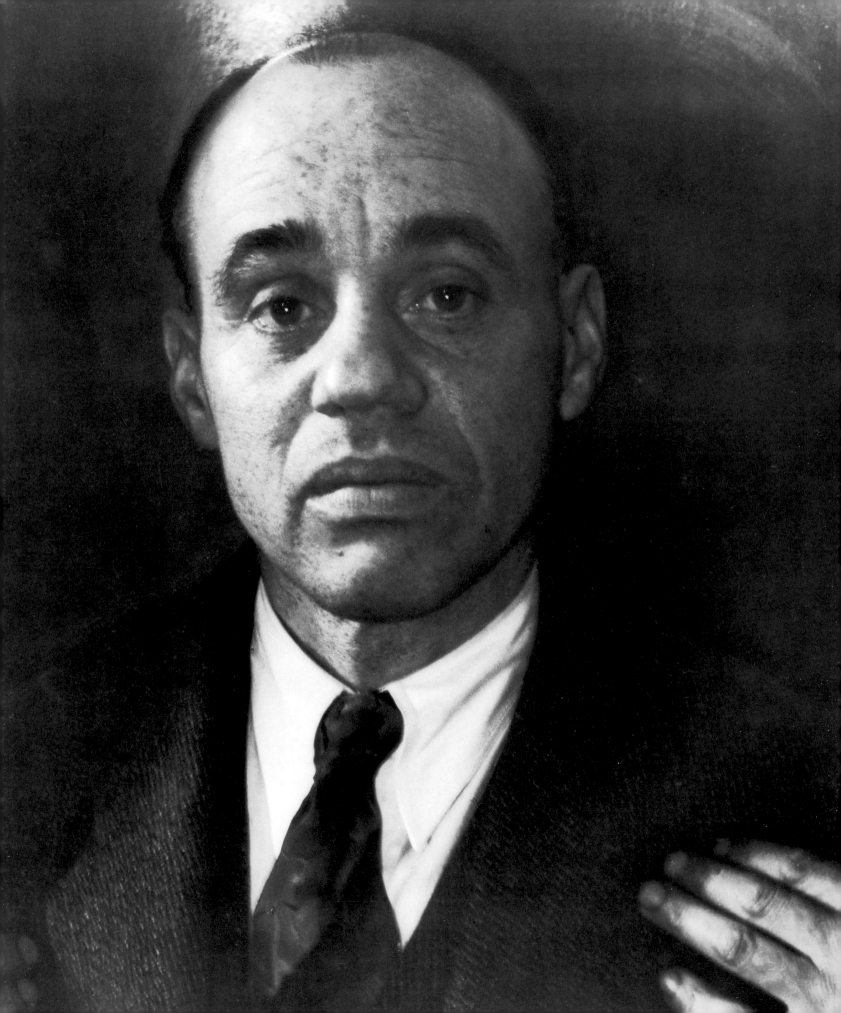

Sargent Claude Johnson and Modernism: An Investigation of Context, Representation, and Identity

Sargent Claude Johnson (1888–1967) was caught between two identities and two concepts of what it meant to be a modern-day Negro in the United States in the first half of the twentieth century. One held up white middle-class values and physiognomy as the ideal, whereas the other was closely aligned with a rediscovery of the black self, spurred by the New Negro movement and the Negro Renaissance of the 1920s. Johnson's artwork reflected this duality from the late 1920s through the late 1930s, when he abandoned the imagery that had brought him acclaim in favor of design concepts in which idealization of the black figure was not important. We can reconstruct Johnson's life and intentions for his work from the images and few documents he left behind. His racialized works are beloved by those who appreciate them for their dignified simplicity that recalls traditional West African sculpture and its identification with a concept of beauty that celebrates the unmixed black physiognomy. In addition to addressing these attractions to his work, this essay suggests how Johnson arrived at his figurative representation and why he later deemphasized racialized characterizations for less specific forms.

Although Johnson experimented with many styles throughout his career, his work can be roughly divided into three stages. The very few early works that survive, such as *Elizabeth Gee* (1927; PL. 2) and an untitled bust from the same year (PL. 1), reveal Johnson's classical sculpture training and its emphasis on realism. They are markedly different from his next period, when he was consumed with a desire to portray only the "pure American Negro." In these works, such as *Forever Free* (1933; PL. 8) and *Negro Woman* (1933; PL. 9), he abandoned the realism of his early pieces for a more exaggerated, stylized view of African Americans. In later works such as *The Bull* (ca. 1960; PL. 29) and *Girl with Braids* (1964; PL. 33), Johnson for the most part dropped both the realism of his earliest works and the racialized images of his middle period for a style that was a response as much to Mexican and African art as to the

Fig. 1
Consuelo Kanaga
Sargent Johnson
1934
Collection of the
Brooklyn Museum
of Art. Gift of Wallace
Putnam from the Estate
of Consuelo Kanaga

Fig. 2
Sargent Johnson
Untitled
1919
Collection of
Mrs. Gilbert Blockton

Abstract Expressionism of his Bay Area contemporaries.

Sargent Claude Johnson (born Sargent Harrison Johnson) was born in Boston on November 7, 1888, the third of six children, to Eliza Howard Jackson and Anderson Johnson.[1] His parentage was mixed: his mother, from Alexandria, Virginia, was African-American and Cherokee Indian; and his father, from Richmond, Virginia, was Swedish-American.[2] The father died in 1897, and the mother, in 1902. Orphaned, the children went to live in Washington, D.C., with a maternal uncle, William Tecumseh Sherman Jackson, a mathematics teacher who became the principal of the M Street High School, and his wife, the sculptor May Howard Jackson, who maintained a studio in her home.

Although the Johnson children's stay with the Jacksons was brief, Johnson's values and artistic career were influenced by this exposure to upper-middle-class life. From the Jackson household, the children were sent to their maternal grandparents' home in Alexandria, Virginia, and after this sojourn they were separated. Johnson and his brothers were sent to the Sisters of Charity in Worcester, Massachusetts, and the sisters to the Catholic School for Indian and Colored Girls in Pennsylvania.[3] The Sisters of Charity sent Johnson to a public school, where he studied music and mechanical drawing. He studied art in night school after working during the day for the Sisters of Charity in their St. Vincent Hospital. In addition, he attended music school at the School of Fine Arts in Boston but chose to pursue the visual arts.[4] He left Massachusetts for Chicago, where he had other relatives, but then moved on to the San Francisco Bay Area in 1915.[5]

Although Johnson is not listed in the San Francisco City directory until 1917, where he is noted as working as a fitter for Schussler Brothers, he must have been employed right away, for he married Pearl Lawson in 1915 and enrolled in the A. W. Best School of Art on California Street shortly after arriving.[6] At the Best School, he studied drawing and painting. Johnson then entered the California School of Fine Arts (CSFA, now the San Francisco Art Institute). During his four years there (1919–23), he studied first with the sculptor Ralph Stackpole for two years and then with Beniamino Bufano. He also studied with Maurice Stern.[7] He continued to work while pursuing his art studies. In 1920 he was listed in the city directory as an artist tinting photographs for Willard E. Worden, and in 1921 as a framer for Valdespino Framers, where he remained for about ten years. None of his early student work remains except for an untitled oil painting (fig. 2). This 1919 landscape with an Isadora Duncan–type dancing figure is his earliest known work and gives an indication of his painting technique at the CSFA, where he won first-prize awards in 1921 and 1922. Johnson continued to work in Bufano's studio independently for another three years, and he

began to present work in local art exhibitions. He left the school in 1923, the year that his only child, Pearl Adele, was born. In 1925 Johnson and his family moved to the East Bay, where he established a studio in his backyard at 2777 Park Street in Berkeley. He maintained his job at the framers in San Francisco and worked in his studio in the evenings and on weekends.

Like his aunt, May Howard Jackson, Johnson preferred sculpting portraits of people he knew. But Johnson, a generation younger than his aunt, had a more complicated response to the racial situation of his time. Jackson, a very light-skinned black woman, made a distinction in the way she portrayed males and females in her portrait busts. The males are depicted with decidedly Negroid features—thick lips, wide nose, tightly curled hair—whereas the females have Europeanized facial features. Her *Unidentified Man* (Virginia State University, Petersburg) and *Bust of a Woman* (see fig. 16) exemplify this dichotomy, underscored by her habit of painting the plaster casts of the male subjects black and the female ones white. Such an assimilationist posture, however qualified, was common among blacks in the late nineteenth century. Jackson chose as sitters accomplished African Americans, such as the poet Paul Laurence Dunbar, people who could serve as models for blacks as they moved from the Reconstruction era into the twentieth century. By contrast, Johnson, who was also light-skinned, did not shy away from the racial features of his sitters, whether they were Chinese American, as in the 1927 *Elizabeth Gee* (PL. 2) or African American, as in the 1931 *Chester* (PL. 5).

Johnson was a product of two "Negro" movements of self-redefinition, one less formal movement taking place in the late nineteenth and the other—called the New Negro movement—taking place in the early twentieth century. The earlier movement asserted that the Negro had to be redefined and re-formed for the modern world, devoid of any reference to the former enslaved condition. The second manifestation, in the 1920s, encouraged a cultural rejuvenation and a celebration of difference (from whites) through an investigation of black folk culture, which promoted a racial or intellectual pride in being African American. Johnson's perception of self and his race were influenced by this second, New Negro, movement.

The first large wave of migrating African Americans after World War I created the urban black communities in New York, Chicago, Detroit, and Washington, D.C., and to a smaller extent those in Los Angeles and the San Francisco Bay Area. In recognition of the changed view African Americans had of themselves and their place in America as a result of their movement from the countryside to the cities, the magazine *Survey Graphic* published in March 1925 a record of a symposium entitled "Harlem, Mecca of the New Negro."[8] This was the first time the phrase *New Negro* was used in the 1920s to characterize the advanced social and cultural position of African Americans. Later the same year, Alain LeRoy Locke expanded on the *Survey Graphic* symposium in his book *The New Negro*, illustrating it with paintings and drawings that portrayed this new consciousness.

Even as the concept of the New Negro gained currency among African-American artists, there ensued a heated debate as to how they should portray themselves. Locke wanted to strike a blow against the black stereotypes of the Reconstruction period, which portrayed African Americans

as grinning, sentimental servants and comic or lustful peasants, primitives who wanted nothing more from life than the pleasures to be had through sex, song, and dance. He encouraged African Americans to look to their African heritage and their folk or slave culture in the United States because that was where they would find the roots of their cultural expressions. In his essay "The Legacy of the Ancestral Arts" Locke argues that since black artists in America lack a mature tradition, rather than imitate white artists, they should use their ancestral arts of Africa to develop a native African-American art.

> The Negro physiognomy must be freshly and objectively conceived on its own patterns if it is ever to be seriously and importantly interpreted. . . . We ought and must have a local school of Negro art, a local and racially representative tradition. . . . In idiom, technical treatment, and objective social angle, it is a bold iconoclastic break with the current traditions that have grown up about the Negro subject in American art. It is not meant to dictate a style to the young Negro artist, but to point the lesson that contemporary European art has already learned—that any vital artistic expression of the Negro theme and subject in art must break through the stereotypes to a new style, a distinctive fresh technique, and some sort of characteristic idiom.[9]

Some scholars have misinterpreted Locke's suggestion that African Americans follow the lesson of modern European artists to mean that their (the African-American artists') validation must come from a European source. On the contrary, Locke suggests that the lesson that could be learned from the European artists was one of a reinterpretation of existing forms to create contemporary ones in line with modernist ideals.[10]

Nineteen twenty-five, the year that the term *New Negro* was coined and that Locke published his philosophic treatise on Negro art and culture, was also the year that Johnson was introduced to the newly formed Harmon Foundation. Established by the New York philanthropist William E. Harmon, the foundation was dedicated to promoting the cultural contributions of African Americans to other segments of the country; its activities included exhibitions of art made by African Americans. Johnson began his exhibition relationship with the foundation in 1926 and enjoyed this patronage until 1939, gaining national (and local) recognition through the exhibitions.[11] The 1930 Harmon traveling exhibition came to the Bay Area, to the Oakland Municipal Art Gallery (now the Oakland Museum of California), where it was sponsored jointly by the Harmon Foundation, the National Council of Churches, and the NAACP. Johnson was also in a second Harmon exhibition that traveled to Oakland the following year, this time sponsored by the Oakland Council of Church Women, the California Federation of Women's Clubs, Northern Section, and the Alameda County League of Colored Women Voters.[12] This exhibition exposure assured that West Coast viewers recognized and appreciated not only Johnson's artwork but also that of other African-American artists. But for Johnson, the only black artist in the exhibition from the West, the honor was even more important, for it established his racial identity in the eyes of a national audience.[13]

Johnson had already become known in the arts community of San Francisco though his studies at the CSFA and exhibitions with the San Francisco Art Association (SFAA), but it was through the Harmon Foundation exhibitions that he reached most of his black audiences in the East Bay. Through financial assistance from friends and

patrons, Johnson had time to become a very active member of the arts community and strengthen his participation in the SFAA.[14] In May 1932 he was elected to membership in the organization and in 1934 to its Council Board. His relationship with the SFAA continued as one of its jurors at the organization's annual art exhibitions in 1936, 1938, 1940, 1942, 1947, and 1948. Johnson also participated in SFAA exhibitions, winning awards in 1931 for *Chester* (PL. 5), in 1935 for *Forever Free* (PL. 8), and in 1938 for a lithograph entitled *White and Black* (fig. 3). He painted murals at two Oakland churches and was a member of the Mural Painters Association, Regional Arts of California.[15] The artist and art historian James Porter has discussed Johnson's murals:

> The formal design employed by Sargent Johnson in his murals is a vigorous if derivative element of Negro mural art. Pardonably e[c]lectic at times, Johnson had dipped for inspiration into the paint pot of the modern Mexican school, and has managed to achieve something of the suppleness associated with Diego Rivera. . . . He leans definitely toward a formalistic compromise with realism, and this leaves his paintings somewhere between the symbolism of Gauguin's "Yellow Christ" and the academic realism of Rivera's California frescos.[16]

Johnson produced his most memorable works in the 1930s, and he continued to exhibit with the San Francisco Art Association through 1938 and the Harmon Foundation through 1939. Nonetheless, the early 1930s must have been a difficult time for the Johnsons financially. His employment with Valdespino Framers ended in 1931 or 1932. Johnson had applied to work on large Works Progress Administration (WPA) projects in San Francisco, but, according to the artist, the WPA would not hire him until a super-

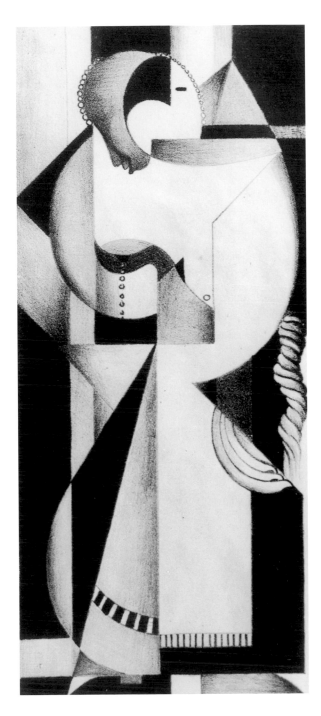

Fig. 3
Sargent Johnson
White and Black
1938

visor of a Federal Art Project (FAP) painting program, Hilaire Hiler, interceded for him. Johnson therefore first worked as an FAP artist for his former teacher Bufano for a couple of years, modeling forms for him in his studio on Mission Street.[17]

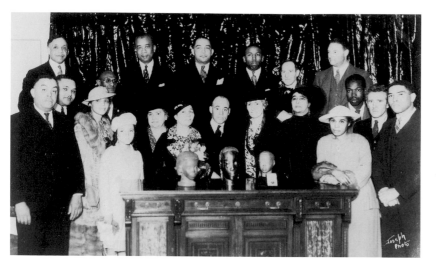

Fig. 4
Joseph Photo
First row (immediately behind table) from left: Pearl Johnson (daughter), Pearl Johnson, Sargent Johnson, and unidentified members of the Alameda County NAACP at the award ceremony where the NAACP presented Johnson with a medal
1935
Collection of Dr. and Mrs. Edwin C. Gordon

Johnson was one of about five sculptors working with Bufano at the time. He modeled small statues and then enlarged them in copper. Other sculptors welded the copper sheets together.[18] Bufano's statue *Peace*, from about 1931, is one of the sculptures on which Johnson worked.[19]

It is therefore not surprising that echoes of Bufano's orblike figures with minimal linear articulation can be seen in Johnson's work from this time, such as his *Forever Free* from 1933 (PL. 8). The form's self-contained stance approximates an Egyptian tomb figure, with "hieroglyphic" toddlers incised at the mother's sides. Even her bent arms and hands can be compared to an Egyptianesque style of representation. Johnson explained that he had been inspired to use polychrome lacquer over wood by examples of Egyptian art. Johnson was able to begin *Forever Free* while Bufano was in Europe; when Bufano returned, however, Johnson had to devote his time to the older artist's *Sun Yat-Sen*.[20] Johnson also made many of the small clay models for Bufano's animals, which were later cast into stone.[21]

Independent of Bufano, Johnson completed a number of works as an FAP sculptor including

Standing Woman (1934; PL. 12); two terracotta pieces, *Negro Woman* (1933; PL. 9) and *Head of a Negro Woman* (ca. 1935; PL. 14); two polychrome wood sculptures, *Forever Free* (1933; PL. 8) and *Negro Woman* (ca. 1935; see fig. 5); and the copper *Mask (Negro Mother)* (1935). These works focused on American black women. By 1935 Johnson was firmly dedicated to representing African Americans and a racialized art form. This subject matter distinguished him from his white art colleagues in San Francisco. The black subject, articulated by a black artist, was a novelty in the Bay Area. Delilah L. Beasley, an African-American writer for the *Oakland Tribune*, wrote that "Negro artists and art students in California for some unknown reason are very shy in giving out information concerning their activities in the study of art. . . . This habit is being broken up especially in Oakland by a recognized artist, Sargent Johnson, who is encouraging such art students to study until they have mastered the actual essentials."[22] According to Beasley, Johnson was the only professional African-American artist working in the Bay Area at the time. Furthermore, compared to the work of other black artists across the country, Johnson's displayed a smooth surface and an economy of line that gave his subject, an everyday black person, a quiet, dignified, but not romanticized, presence. As the premier African-American artist in the Bay Area, Johnson was awarded a medal in March 1935 by the Alameda County Branch of the National Association for the Advancement of Colored People (NAACP; fig. 4). In the Harmon Foundation's 1935 catalogue, *Negro Artists: An Illustrated Review of Their Achievements*, he was described as "one of the outstanding Negro sculptors in the country. . . .

Sargent Johnson's work in sculpture is notable for its clean simplicity, directness and strength of conception and execution. One's impression is of complete freedom from technical virtuosity for its own sake. The theme is presented without unnecessary or disturbing detail and gives a sense of sure and effortless confidence."[23] So, with his exhibition record with the SFAA and the Harmon Foundation behind him, encouragement from the African-American community of the Bay Area, and his new relationship with the FAP, Johnson confidently stated his position on his art and his representation of African Americans in an interview in the *San Francisco Chronicle* in October 1935:

> I aim at producing a strictly Negro Art, . . . studying not the culturally mixed Negro of the cities, but the more primitive slave type as it existed in this country during the period of slave importation. Very few artists have gone into the history of the Negro in America, cutting back to the sources and origins of the life of the race in this country. It is the pure American Negro I am concerned with, aiming to show the natural beauty and dignity in that characteristic lip, that characteristic hair, bearing and manner.
>
> And I wish to show that beauty not so much to the white man as to the Negro himself. Unless I can interest my race, I am sunk. And this is not so easily accomplished. The slogan for the Negro artist should be "go South, young man." Unfortunately for too many of us it is "go East, young man." Too many Negro artists go to Europe and come back imitators of Cézanne, Matisse, or Picasso. And this attitude is not only a weakness of the artists, but of their racial public.
>
> In all artistic circles I hear too much talk and too much theorizing. All their theories do not help me any, and I have but one technical hobby to ride. I am interested in applying color to sculpture as the Egyptians, Greeks, and other ancient peoples did. I try to apply color without

destroying the natural expression of sculpture, putting it on pure, in large masses, without breaking up the surfaces of the form, respecting the planes and contours of sculpturesque expression. I am concerned with color not solely as a technical problem, but also as a means of heightening the racial character of my work. The Negros are a colorful race. They call for an art as colorful as it can be made.[24]

These words, combined with the racialized images produced in the 1930s, became an indelible signature of Johnson's career and affected how his work was contextualized for the rest of his life.

This framework for viewing African Americans was very limited. Johnson defined the physical attributes of a "pure American Negro," and it appears that he chose to represent only that type in his work. But where could he find the "pure Negro"? Johnson felt that she was located in the South, and he encouraged African-American artists to go South to find the characteristic "primitive slave type" there. The South was viewed by many as the home of the African American, and many spoke out in its defense. Yet Johnson went South only once, to New Orleans, where the archetype of the mammy image (read "primitive slave type") is preserved and has continually been commercialized as dolls, pot holders, and other kitchen aids in the tourist section of the French Quarter.[25]

Johnson's "primitive slave type," with "that characteristic lip, that characteristic hair," is closely tied to stereotypical representations of blacks that contextualize African Americans in a monolithic physical frame. He positions himself as an inside interpreter of African-American culture, but not as a participant. For Johnson, pure racial types referred to a person's physiognomy. Physiognomy, especially skin color, thus became the

yardstick in determining one's racial makeup. The purest racial type in the United States was described in the literature and visual arts of the day. Langston Hughes in "The Negro Artist and Racial Mountain" speaks of "our individual dark-skinned selves," and Johnson, in his *San Francisco Chronicle* article, refers to "a strictly Negro art, . . . not the culturally mixed [also read racially mixed] Negro of the cities, but the more primitive slave type as it existed in this country during the period of slave importation."[26]

Johnson completed three major sculptures of full-bodied dark-skinned black women, two with their heads wrapped in a cloth. These strong, nurturing women, their physiognomy and dress closely resembling the asexual, heavy-set Mother Earth figure that nursed white babies and listened to their parents' problems, were characterized by Donald Bogle as an archetype in Hollywood films.[27] Although the characterization of Johnson's figures as mammies is difficult to escape, he did attempt to dignify them. He sought women in the urban communities of Northern California who fit his characterization of the "pure American Negro." For example, the woman who posed for *Forever Free* worked as a domestic in his neighborhood.[28] *Forever Free,* and particularly *Negro Woman* (fig. 5), can also be compared to Diego Rivera's representation of peasant women in his murals. Although Johnson did not see Rivera's murals in Mexico until he traveled there in 1945, his teacher and colleague Ralph Stackpole brought Rivera to San Francisco in 1930 to paint the fresco at the Pacific Stock Exchange, and Johnson would have been familiar with Rivera's style.[29] It was easy for Johnson to relate to Rivera's representation of peasantry. African Americans were the peasants of the United States and had been objectified as such in American paintings since the eighteenth century. In *Negro Woman,* the barefoot white-garbed kneeling figure is characterized by an economy of lines, earthbound weightiness, and quiet dignity that comes through in many of Rivera's works. With his focus on the folk and indigenous cultures of Mexico, Rivera consistently tied his figures to the land. Although Johnson was apolitical in the sense that he was not involved in any organized political or social movements, he developed this strategy of racial representation vis-à-vis his African-American subjects, informed by the New Negro movement as well as the Negro Renaissance in Harlem and other urban centers and Rivera's representation of the Mexican peasant woman.[30]

Johnson rarely represented obviously racially mixed people in his work of the 1930s, choosing blacks who showed fewer signs of mixed heritage. He also located his mainly female subjects among the working poor. *Standing Woman* (PL. 12) is just over fifteen inches high, yet its small size is empowered by its presence. The lips are full and eyes well rounded to comply with what Johnson believed to be the essence of the pure Negro. The hair is tied back into a low bun, looking as if it is wrapped in a scarf. The figure is stout, with full limbs and a straight thick body that shows little definition at the waist between the once-full breasts and the squared-off hips. She is completely covered by a long dress that removes any hint of her being an object of sexual desire. Her clothing, matronly rather than stylish, signifies her position in society. She is not of the black middle-class intelligentsia, as was his aunt, May Howard Jackson. Had she been, her hair would have been styled as it is in Jackson's

Bust of a Woman (see fig. 16), or perhaps topped with a smart hat rather than a head "rag." Her clothing would have been stylish for the period, streetwear rather than clothes for housecleaning; her air would have been one of confidence, rather than resignation.

Johnson's concentration on the mammy figure was a subversive act in redefining a stereotypical archetype that was presented in both fine and popular art as a comic and degrading portrayal of black women. But Johnson and his philosophy on racialized art seemed to waver between the positions of Locke and Porter,[31] perhaps because he seemed unclear of his own motives for creating a racial art. As Locke had urged, Johnson referenced an African past in his sculpture, evident in his techniques as well as representation of Africanized masked or self-contained figures. A consciousness of African art, particularly masks and statuary, helped Johnson develop African racial types in his work. Some writers, however, did not see Johnson's connection to African art. James Porter, for example, felt that Johnson's copper masks were imitative and cites the heads *Sammy* and *Chester* (PL. 5) as being "closer to Egyptian portraiture of the Amarna period than to Ivory coast or Sudanese forms."[32] Verna Arvey, writing for *Opportunity,* found yet another source for Johnson's copper masks: "the simple, beautifully proportioned, perfectly balanced and symmetrical and modeled [African heads]—were not from genuine African subjects—but from the various Afro-American faces he saw in his daily round in Northern California"[33] (PLS. 4, 10, and 11). Johnson must have told Arvey that he took elements of faces—eyes, noses, chins, and mouths—from different people and created his masks by surmounting them with "primitive headdress[es]."[34] These

Fig. 5
Sargent Johnson
Negro Woman
ca. 1935
Cat. No. 17

masks illustrate an interest in a "primitive slave type" as well as the articulation of an Africanized technique in mask making.[35] But the issue of a "pure native" presented problems for him and other artists in the long term. Johnson also focused on African-American folk expressions. In this regard, he followed Porter's advice to concentrate on a homegrown African-American culture rather than an African one; the latter, Porter felt, had little chance of cultural survival.

If Johnson's female subjects made the 1930s a banner decade for his artistic career, his personal life suffered. He and his wife separated in 1936.[36] His daughter, Pearl, remained with her mother in Oakland until the mother was hospitalized in 1947 and sent for treatment of a mental disorder to the Stockton State Hospital, where she died in 1964.[37] After 1935 Johnson spent much of his

time in San Francisco's North Beach. Estranged from his family physically, Johnson became a regular there, among his white artist friends.[38]

Johnson used his art as a means of repatriation by restoring pride in a physiognomy that had been defiled in the popular media and that was embarrassing to some members of the black middle class. He denounced racist and degrading imagery by reconstructing previously held stereotypical images, giving them new meanings. He applauded the difference in the African-American physical self from that of Europeans, countering images of assimilation or miscegenation. But, just as identity politics is subjective and has vacillated through time, so did Johnson's images. The complexity of identifying and adhering to a specific racialized art became too problematic and limiting for Johnson and, in the end, had to be abandoned. The language of racial purity lessened later in the 1930s, primarily because it was "racial purity" that drove the genocidal machine of Adolf Hitler. Johnson realized that tightly contextualized racial images limited his freedom of expression. In addition, it was difficult for him to ignore the art world of San Francisco, where abstraction became the topic of discussion and locus of creative production. As a result of winning large public art commissions from the FAP, his focus began to change, allowing him to broaden his thematic possibilities. Johnson said of the WPA:

> It's the best thing that ever happened to me because it gave me more of an incentive to keep on working. At the time things looked pretty dreary and I thought about getting out of it because, you know, I came from a family of people who thought all artists are drunkards and nothing else. I thought I'd given it up at one time but I think the WPA helped me to stay.[39]

Johnson's first public project with the FAP was in Berkeley in 1937. This large project was for the California School of the Blind, for which he carved two redwood organ screens in high relief.[40] Most of the carving was done in Johnson's Berkeley studio. Although the screens contain stylistic similarities, thematically they seem worlds apart. The first screen features three singing masklike heads of women in the central panel, and in a panel to the left a silhouetted profile of a woman with cropped hair bears a striking resemblance to Josephine Baker. The masks are uniquely Johnson's, recalling his Africanized copper masks, and are racially specific, lauding the contribution of African-American music to the world by the inclusion of the singing heads. In the second screen the figures appear to be inspired by St. Francis of Assisi. There are two figures, one seated and playing a tambourine; in an adjoining panel, a figure gazes upward as a spiral of birds ascends toward a set of bells. Animals, among them deer and rabbits, gather in peaceful harmony.

Two years later, in 1939, through Hiler's assistance, Johnson was named a supervisor on the Aquatic Park project in San Francisco, a distinction accorded only one other African American during the lifetime of the FAP. Johnson decorated the entrance of the bathhouse, carving into green Vermont slate scenes of work and play by the water, as well as providing a colorful mosaic of abstracted fish on the veranda wall (fig. 6). These works illustrate a turn from racialized forms to a concentration on abstracted shapes and designs. The Aquatic Park project was Johnson's first project of his own with the San Francisco FAP, and, as a supervisor, he coordinated the project, employing and supervising other artists.[41]

With the FAP over, Johnson returned to the

CSFA from 1940 to 1942 for further study. In 1940, after the San Francisco Art Commission had awarded a project to Bufano and then rescinded it because of problems with his proposed design, Johnson applied for and was awarded the job.[42] The award of the project to Johnson angered Bufano. This incident ended their personal and professional relationship.

The project was a frieze to run along a retaining wall at the end of the football field at George Washington High School. Johnson reworked Bufano's drawings and submitted a maquette. Once approval was secured, Johnson created a frieze of athletes in a procession, illustrating competitive sports with the figures in constant motion. Here Johnson returned to a realistic figurative form, in the style of his early mentor, Diego Rivera. In a slightly more Art Deco style, Johnson created athletes, especially female swimmers, who closely resemble Rivera's swimmers in his *Pan American Unity* mural (figs. 7, 8).

In 1939, six years after Johnson created *Forever Free* and four years after the famous text of 1935 in which he articulated his ideas on race and representation, Johnson was interviewed by Verna Arvey for the journal *Opportunity*. Arvey explained that Johnson was currently "interested in abstract art, or pure design," continuing that

> he has not swung toward the ultra-modern, nor yet toward what is termed "proletarian" art, though many of his acquaintances deride him for his failure to do so. . . . They tell him that he is living in another world. They try to persuade him to awaken from his sleep and to change his

style so that it will conform to *their* ideas. He has not heeded their arguments, for he believes that art is no longer art when it is burdened with a political significance. Further, he knows that the working people themselves don't like to be portrayed as the proletarian artist paints them. They are sure they don't look as awkward, as earthy, and as unbeautiful as that.[43]

By this time, Johnson's views on a racial art had changed, and he was moving toward Abstract Expressionism. The proletarian artist to whom Arvey refers continued to advocate a social consciousness in artwork through the platforms of communism or socialism.[44] As one who shunned organized politics, Johnson refused to make his art serve propagandistic purposes. At

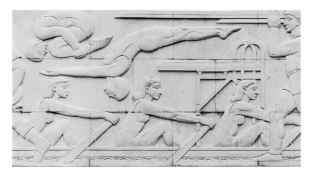

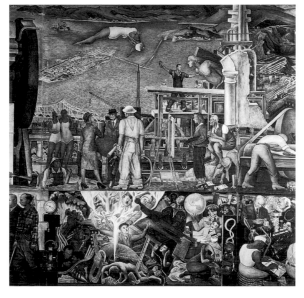

Fig. 6
Sargent Johnson
Untitled (sketch for the bathhouse at Aquatic Park [now the San Francisco Maritime Museum])
1938

Fig. 7
Sargent Johnson
Untitled (George Washington High School Athletic Field frieze) (detail)
1942

Fig. 8
Diego Rivera
Pan American Unity (detail)
1940
City College of San Francisco

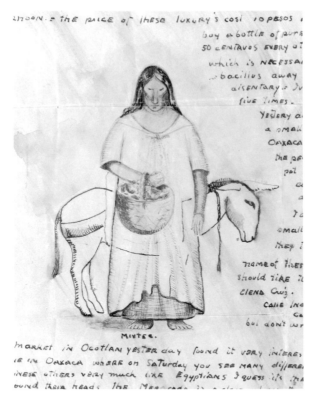

Fig. 9
Letter from Sargent
Johnson to Judge
and Mrs. Walter A.
Gordon, April 20,
1945, Oaxaca, Mexico
(detail)
Collection of Dr. and
Mrs. Edwin C. Gordon

the end of the 1930s and continuing into the 1940s, therefore, Johnson concerned himself with the fluid movement of line that he had exhibited in the Aquatic Park project. He pulled several lithographs, including *Lenox Ave* (1938; PL. 16), *Dorothy C.* (ca. 1938; PL. 15), and *Singing Saints* (1940; PL. 17), and in these pieces we see a more graceful lyricism that was not present in his racial sculptural works.[45] The racial identity of the "slave type" is also blurred if not benign.

Johnson's mosaic work at Aquatic Park led to an interest in ceramics. He exhibited his ceramic work, participating in the American Negro Exposition in Chicago in 1940; *The Negro Artist Comes of Age* at the Albany Institute of History and Art in Albany, New York, in 1945; and the *Eleventh National Ceramic Exhibition* in Syracuse, New York, in 1946–47. He also continued to exhibit at home, in *California*

Art Today, at the Palace of Fine Arts, San Francisco, in 1940; and *Art of Our Time*, at the San Francisco Museum of Art, in 1945. Few of his ceramic pieces have survived; only several teapots, cups (PL. 20), a small beautifully glazed *Negro Mother* mask pendant, and an assortment of plates remain.

As he became more involved with crafts and began to study the art practices of other cultures, specifically African and Pre-Columbian, Johnson's interest in travel grew. He applied for and received an Abraham Rosenberg Scholarship to travel to Mexico in 1944 and 1949. In his application for 1944 he discussed his interest in polychromy and the use by contemporary sculptors of archaeological material from "Egypt, Greece, the Orient, the Middle Ages and primitive societies."[46]

In Mexico in 1945, Johnson met David Alfaro Siqueiros. In a letter to the secretary of the School of Fine Arts, Johnson commented on Siqueiros's use of Duco cement with its powerful color but nonetheless felt Siqueiros's work was not as good as that of José Clemente Orozco.[47] Johnson reported on a visit to the Palace of Fine Arts in Mexico City to see frescoes by Rivera, Siqueiros, and Orozco and to the National Museum of Anthropology, where he spent several days studying the sculpture and pottery. His interest in early civilizations took him to Veracruz and the Pyramid of Tenayuca, as well as several monasteries. He stayed in Cuernavaca to see the murals of Rivera. While visiting Oaxaca, he became interested in the region's gray clay that turns black when fired and was traditionally used to create beautiful pots.[48] In later years he returned to Oaxaca and other places in southern Mexico to explore his interest in the Oaxacan clay, the archaeological sites, and the Chelula polychrome

pottery.[49] Johnson's *Primitive Head* (1945; PL. 21) resembles in size and simplicity some of the smaller ruins he saw in Mexico. This and other hybrid forms such as *Young Girl* (fig. 10) are aesthetically successful works from this period.

From the end of the 1940s into the mid-1960s, Johnson continued to participate in local art exhibitions and to seek private commissions. This became more difficult as abstract painting grew in importance in the Bay Area, first because of Hans Hofmann's teaching at the University of California at Berkeley in the early 1930s and then with Clyfford Still and Mark Rothko's teaching at the CFSA in the 1940s, where they influenced David Park, Elmer Bishoff, Ed Corbett, and Richard Diebenkorn. Not wanting to abandon the figure entirely, Johnson continued to investigate the forms that he had in the past, but with an increasing simplification and economy.

About 1947 Johnson met one of the owners of the Paine-Mahoney Company, which produced porcelain-on-steel signs. Mastering the technique, Johnson secured commercial jobs, such as the facade of panels of enamel on steel (1948) on Nathan Dohrmann & Company, a crockery and glass store in Union Square, and a tile panel at Harold's Club in Reno, Nevada, in 1949. In both he experimented with the fluid movement of paint. These commercial commissions allowed him time to pursue his own work and an opportunity to experiment with new materials. During this period he also completed an enamel-on-steel work for the Richmond (California) City Hall Chambers, in 1949. For the Matson Navigation Company's SS *Lurline* Johnson carved a mahogany panel (1948) and was again commissioned by the Matson Company in 1956 to design two mosaic ceramic tile walls for the SS *Monterey*. This would

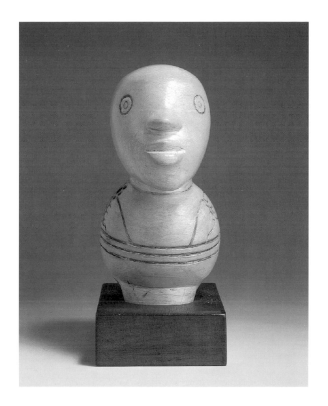

Fig. 10
Sargent Johnson
Young Girl
n.d.
Collection of the Oakland Museum of California, Museum Donors Acquisition Fund

be his last commissioned work. In later years Johnson executed several paintings on steel, such as the small panels *Bull* (ca. 1960; PL. 29), and *Four Sisters* (1963; PL. 27), and the larger *Singing Saints* (1966–67; PL. 18), based on the 1940 lithograph of the same name (PL. 17).

By now, the concept of the New Negro in a modern world had further broadened for Johnson, thanks to contact with customs and artwork from countries that bordered the Pacific Ocean and his investigations into African art. The Bay Area provided many opportunities for Johnson to investigate those works through the examples exhibited in its museums. Although he lived and worked in an artistic milieu that was interested in diverse cultures, Johnson's investment in the cultures of Africa and Mexico ran deeper than that of his colleagues, for he gave importance to the people who created the art forms and did not

separate the forms from their creators, making the art and its origins of utmost importance in helping him to understand himself. Johnson sought racial purity in his African-American characterizations, fueled by his interest in looking at people to see their stories, as well as by his search for his own identity.

Without the large commissions, Johnson had to find jobs. He worked intermittently for Flax Framing and Art Supply Company as a framer in his later years. He moved to Telegraph Hill in San Francisco in 1948 and shared a studio at 1507 Grant Avenue with John Magnani, a close friend from the 1930s.[50] There he produced clay pieces and collaborated with Magnani to develop glazes. As a chronic illness worsened in 1965, Johnson's residence changed several times. At the end of his life he was in a small hotel room in downtown San Francisco, where he died of a heart attack in 1967.

Even as Johnson's later sculptures became more minimal, he still sought a less restricted form in which to work. He created some smaller enamel pieces for himself such as *Mask, No. 1* (1966; PL. 38), and an untitled self-portrait (1966; PL. 39), similar to the ones he had done commercially, exploring geometric forms that suggest the influence of de Kooning's figuration. These works also exhibit an introspection, which may indicate Johnson's attempt to come to terms with his racial identity, not by focusing on how black people look but on his own inner self. The self-portrait shows a sullen Johnson, who had always been described as "happy-go-lucky" by friends and good company for drinks and laughs. He seems tormented here, as a bright circular light penetrates the center of his forehead. If we read this in Jungian terms (Jungian theory was popular among North Beach artists of the 1960s), we would say that Johnson is drawing from the unconsciousness and does not adhere to the general expectations of his viewers for black representation. Instead, his work shows a growing tendency to withdraw from observed objects. Because the "inside" of which Jung writes is situated behind consciousness, it is invisible and cannot be imagined, even though it affects the consciousness. Jung further writes that the aim of this type of abstract expression is to make the contents of the unconscious accessible and to bring them forward to consciousness.[51]

Most of Johnson's works from the 1960s are untitled, giving no clue as to how they are to be read by the viewer. They also possess what Jung has described in Picasso's work as "lines of fracture—a series of psychic faults (in the geological sense) which run right through the picture." The use of these psychic faults, Jung continues, "leaves one cold, or disturbs one by its paradoxical, unfeeling, and grotesque unconcern for the beholder."[52] Johnson completed his untitled self-portrait the year before his death. It seems clear that he was trying to reach areas of his subconscious, for as Jung said, "He is the greater personality who bursts the shell, and this shell is sometimes—the brain."[53]

Notes

1. Copy of record of birth from the Commonwealth of Massachusetts, no. 425,039. Johnson's name is listed as Sargent Harrison Johnson. Evangeline J. Montgomery's exhibition catalogue from 1971, *Sargent Johnson: Retrospective*, gives his name as Sargent Claude Johnson and birth date as October 7, 1887. Montgomery notes that Johnson had a brother named Harrison and that Sargent adopted the middle name Claude. Also see transcript of Mary McChesney interview with Sargent Johnson, 2 Cadell Place, San Francisco, July 31, 1964, p. 1, the Paul C. Mills Archive of California Art, The Oakland Museum of California. In this tape-recorded interview, Johnson first said that he was born in Boston, but later in the interview he stated Winston, a locale that is now impossible to trace.

2. Copy of record of birth.

3. Montgomery, *Johnson: Retrospective*, p. 10.

4. Ibid. Johnson said that he first attended art school in Boston for about two years; McChesney interview, p. 1.

5. Ibid.

6. Ibid., and *San Francisco City Directory*, 1917–18. *Fitter* is a period term for framer.

7. Ibid., and McChesney interview, p. 1. Johnson was friends with all three artists. Stackpole was influential in Johnson's artistic life: he probably introduced Johnson to the work of Diego Rivera, whom Stackpole brought to San Francisco in 1930 to paint the *Allegory of California* mural at the Pacific Stock Exchange; Stackpole may have recommended Johnson for participation in the Golden Gate Exposition at Treasure Island in 1939, where Johnson cast his large stone *Incas* for the Court of Pacifica (also known as the Panama Pacific Court). Johnson was working for Bufano in his sculpture studio when he created his cylinder-like sculpture *Forever Free* in 1933, which shows Bufano's influence. Leon Liebe's purchase of *Forever Free* was reported in Ralph Stackpole, "Montgomery Street Gossip," *San Francisco Art Association Bulletin* 1, no. 6 (October 1934): 1. Sterne's influence probably pointed Johnson in the direction of abstraction. He was known to have an aversion for the effect that Mexican muralists had on San Francisco artists. See Thomas Albright, *Art in the San Francisco Bay Area, 1945–1980: An Illustrated History* (Berkeley and Los Angeles: University of California Press, 1985), p. 11.

8. James A. Porter, *Modern Negro Art* (New York: Dryden Press, 1943), p. 98.

9. Alain LeRoy Locke, ed., *The New Negro* (1925; reprint, New York: Maxwell MacMillan International, 1992), pp. 264–66.

10. The misinterpretation has usually been among scholars from fields other than art history, who have not considered the larger American art canon when investigating and discussing Locke and his impact on African-American artists. African-American artists did not and do not live and work in a vacuum unaffected by trends in the broader American art production.

11. Johnson won the Otto H. Kahn prize for *Sammy* in 1927, the year May Howard Jackson was one of the eight jurors. He also won a Bronze Award in Fine Arts in 1929 and the Robert C. Ogden prize in 1933, all of which are listed in the Harmon Foundation catalogues for those years.

12. Montgomery, *Johnson: Retrospective*, p. 12.

13. See Douglas Daniels's discussion in *Pioneer Urbanites* (Berkeley and Los Angeles: University of California Press, 1980), p. 55. Daniels discusses the nineteenth-century practice for blacks in San Francisco, if possessed of a Europeanized physical appearance and light enough skin color, to reveal their racial identity only if challenged.

14. It was often taken for granted by the larger arts community in the 1920s through the 1940s that African-American artists like Johnson were not innovative or engaged in the aesthetic concerns that characterize Euro-American modernism because one of their primary concerns was that of delineating the black subject. But as the critic Thomas Albright notes, Johnson was one of the more innovative artists of the late 1930s, along with Ralph Stackpole, Giottardo Piazzoni, and Helen Forbes. Albright points out that they all lived in North Beach, between Russian and Telegraph hills, and many had studios in the area. Albright, *Art in the San Francisco Bay Area*, p. 4.

15. Alain LeRoy Locke et al., *Negro Artists: An Illus-*

trated Review of Their Achievements, Including Exhibitions of Paintings by the Late Malvin Gray Johnson and Sculptures by Richmond Barthé and Sargent Johnson (New York: The Harmon Foundation, Delphic Studios, 1935), p. 11, and Montgomery, *Johnson: Retrospective*, p. 16.

16. Porter, *Modern Negro Art*, p. 118.

17. McChesney interview, p. 4.

18. Ibid., p. 5. This was also the same period that Johnson sculpted his copper Africanized masks. Perpetually short of money, Johnson used media that were at hand.

19. Ibid. *Peace,* long installed at the entrance to the San Francisco International Airport, was taken down in 1996 due to construction.

20. McChesney, interview, p. 7. *Sun Yat-Sen* is in St. Mary's Square, off Grant Avenue, in San Francisco.

21. Ibid. Throughout the interview with McChesney Johnson discussed Bufano, whom he felt stifled him. Johnson complained that Bufano did not want him to have his own FAP projects. "Benny wanted me, so I had to go [work for him]. So, I kept telling Benny, I said, 'Gee whiz, I want to get something of my own, you know.' But, I wasn't able to do that until later on." Ibid., p. 22.

22. Beasley quoted in "News of Happenings in the Field of Negro Art," *Exhibition of Productions by Negro Artists* (New York: The Harmon Foundation, 1933), p. 17.

23. Locke, *Negro Artists*, p. 11.

24. "San Francisco Artists," *San Francisco Chronicle,* October 6, 1935, p. D3.

25. Montgomery, *Johnson: Retrospective*, p. 9.

26. Langston Hughes, "The Negro Artist and Racial Mountain," *The Nation* 122, no. 3181 (1926): 622–24, and *San Francisco Chronicle,* October 6, 1935.

27. Donald Bogle, *Toms, Coons, Mulattoes, Mammies, and Bucks: An Interpretive History of Blacks in American Films* (New York: Viking Press, 1973).

28. Telephone interview with Evangeline J. Montgomery, October 21, 1996.

29. It is likely that Johnson would have seen the Rivera retrospective at the California Palace of the Legion of Honor, in San Francisco, from November 15 through December 25, 1930.

30. Verna Arvey, "Sargent Johnson," *Opportunity Journal of Negro Life* 17 (July 1939): 213, mentions Johnson's apolitical stance, which was also confirmed in an interview with Montgomery, December 6, 1996. The Negro Renaissance is most often referred to as the Harlem Renaissance, an African-American cultural rebirth, with Harlem as its Mecca.

31. Although Porter's *Modern Negro Art* was not published until 1943, he wrote articles on black artists, including one in the 1935 Harmon Foundation catalogue cited earlier.

32. Porter, *Modern Negro Art,* p. 105.

33. Arvey, "Johnson," p. 214.

34. Ibid.

35. Johnson also made several abstract masks which are stylistically derivative of African masks. See the backgrounds of both *Dance Hall*s (PLS. 23, 24).

36. Montgomery, *Johnson: Retrospective*, p. 10.

37. Interview with Montgomery, December 6, 1996. Johnson's daughter lived with relatives, but as an adult was hospitalized, also for a mental disorder.

38. Telephone interview with Montgomery, October 12, 1996. Montgomery reiterated that Johnson worked, shared studios, and associated with white colleagues in North Beach. The other black artists working in the early 1930s in the Bay Area were art students. Johnson was the only black artist working as a professional in the early 1930s. By the mid-1930s Thelma Johnson Streat and later Lester Mathews worked for a brief time as professional artists in the Bay Area. Johnson encouraged Mathews, also a sculptor, to pursue his art career, hiring him to work as one of his assistants for the FAP on the carved redwood panels at the California School for the Blind. Lena M. Wysinger, "Activities among Negroes," *Oakland Tribune,* October 29, 1939. An early proponent of multiculturalism, Johnson Streat composed paintings of abstract designs, and the images, especially animal forms, were interpretations of the art of indigenous people. Her most well known work, *Rabbit Man* (The Metropolitan Museum of Art, New York), seems to be a combination of Oceanic and African references. Further research is needed to determine the exact sources of her designs. Harlan Jackson and Charles Darkins, two other

black artists, worked in San Francisco in the mid-1940s. It was not until the 1950s and 1960s, the Beat era, that more black writers and artists began to frequent the area. Many of Johnson's works are owned by former colleagues and friends, and most of these people are of Italian descent. A few African Americans in the Bay Area acquired works in the 1960s. Also see Mona Lisa Saloy, "Black Beats and Black Issues," in Lisa Phillips, *Beat Culture and the New America, 1950–1965*, exh. cat. (New York: Whitney Museum of American Art, 1995), p. 155.

39. McChesney interview, p. 26.

40. David Gebhard, *The Architectural/Historical Aspects of the California School for the Blind and California School for the Deaf, Berkeley (1867–1979)* (Berkeley: The Regents of the University of California, 1979), p. 129.

41. In the McChesney interview Johnson said that he had previously held positions as artist, senior sculptor, assistant supervisor, and assistant state supervisor before achieving this rank, where he employed at least fifteen people and at one time supervised forty-five people. Supervisors could make as much as twice the money an artist made. McChesney interview, p. 20. McChesney's interview centered on Johnson's involvement with the FAP. He stated that Hilaire Hiler, Clay Spohn, Beniamino Bufano, and John Magnani were also supervisors on the project.

The only other African-American artist to achieve the rank of supervisor of an FAP program was Charles Alston, when he was appointed supervisor of a painting program in New York. Charles Alston interviewed by Albert Murray, October 19, 1968. Transcript in Charles Alston Papers, Archives of American Art, Smithsonian Institution, Washington, D.C.

42. See the *San Francisco Chronicle:* June 12, 1940, p. 12; June 26, 1940, p. 14; November 14, 1940, p. 1; November 19, 1940, p. 1; November 20, 1940, p. 12; November 23, 1940, p. 9; November 25, 1940, p. 12; and November 27, 1940, p. 7. Also see Johnson's comments in McChesney interview, p. 8.

43. Arvey, "Johnson," p. 213. Many artists were not doggedly following the mandate of socialist and communist manifestos. Both parties articulated issues and means of solving problems of the larger society that attracted African-American artists.

44. Arvey could have been referring to any number of artists; however, Charles White, Elizabeth Catlett, and John Wilson were more politically involved than Johnson.

45. These were probably printed in FAP workshops, a deduction from the fact that *Dorothy C.* entered several museum collections with FAP collections.

46. Abraham Rosenberg Scholarship application, 1944, p. 2. Sargent Johnson Papers, Library, San Francisco Art Institute.

47. Sargent Johnson to Miss Sullivan, secretary of the School of Fine Arts, San Francisco, received by them February 14, 1945. Johnson Papers, Library, San Francisco Art Institute.

48. In a letter to friends, Johnson mentioned his interest in the clay and wrote, "I also made a few small figures myself hope they turn out." Letter from Sargent Johnson to Judge and Mrs. Walter A. Gordon, April 20, 1945.

49. Specific information on Johnson's trip to Mexico is located in his papers, Library, San Francisco Art Institute.

50. Ibid., and conversation with Margery Magnani, wife of John Magnani.

51. Carl G. Jung, *The Spirit in Man, Art, and Literature,* Bollingen Series 20 (New York: Pantheon Books, 1966), p. 136.

52. Ibid., p. 137. This statement is not intended to suggest that Jung regarded Picasso as psychotic; nor do I regard Johnson that way. But Jung's analysis of Picasso's abstraction (which he compares to the works of James Joyce) suggests a similar reading of Johnson's later work. Johnson's work of the 1960s can also be compared with Bob Kaufman's poetry, which also attempted to access the "inside" that Jung discusses.

53. Ibid., p. 141.

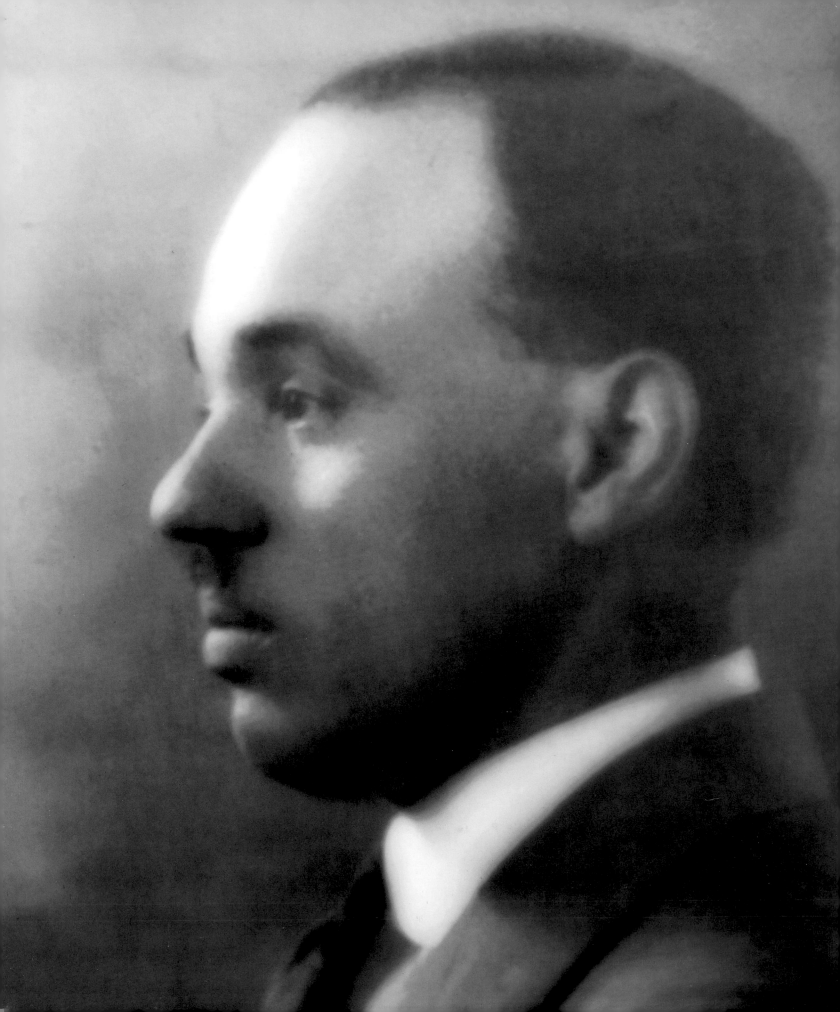

Judith Wilson

Sargent Johnson: Afro-California Modernist

Until recently, most accounts of modernism in American art have ignored race and minimized region as productive factors. But, as scholars shift from viewing "modernism" as a discrete entity to seeing it as a necessarily relational term, geography—as both literal place and symbolic position—becomes central to our understanding of modernism's protean character.[1] Race tends to deterritorialize difference in one sense, positing biological essences that remain unchanged despite transport across continents and over seas. But because it also imposes social boundaries, race can produce symbolic geographies and actual socialscapes. Thus, it seems useful to consider ways in which being an African-American artist in early- to mid-twentieth-century California placed Sargent Johnson in a unique position in relation to modern art and modern life.

Sargent Johnson operated at the intersection of an emergent Afro–United States modernism and an emergent California, or better, Bay Area modernism. Although Grafton T. Brown, an African American who was a commercial lithographer and landscape painter, had lived in San Francisco as early as the 1860s, and work by the sculptor Edmonia Lewis had appeared at the San Francisco Art Association in 1873, black practitioners of the visual arts rarely surface in California history prior to Johnson's emergence in the late 1920s.[2] Indeed, when the Oakland Municipal Art Gallery (precursor to the Oakland Museum of California) hosted the Harmon Foundation's traveling exhibitions of Negro art in 1930 and 1931, Johnson is said to have been "the only Californian" included.[3] Although other African-American artists were active in California at the time, Johnson alone achieved a national reputation.[4]

If Johnson's status as an artist who was professionally prominent and black is singular in the history of early modern California art, so too is his place in the early modern history of African-American art. Alone among United States black sculptors of his time, he was hailed as the producer of work that suc-

Fig. 11
Unknown
Portrait of Sargent Johnson
n.d.
Photographs and Prints Division; Schomburg Center for Research in Black Culture; The New York Public Library; Astor, Lenox, and Tilden Foundations

cessfully combined "the modernist mode" with an "essentially racial" treatment of subject matter.[5] It seems likely that the origins of Johnson's averred preoccupation with "producing a . . . Negro art" predate his arrival in California.[6] But I would argue that conditions unique to the San Francisco Bay Area in the years between the two world wars enabled the artist's realization of his goal.

Sargent Johnson and European modernism reached California about the same time. Before 1915, although a few Bay Area artists went abroad "to study modern art," the majority were forced to rely on sketchy reports and black-and-white images in art journals for news about recent developments in Europe and on the East Coast.[7] As a result, San Francisco's Panama-Pacific International Exposition of 1915 is generally credited with giving local artists their "first full-fledged introduction to modern art."[8] By pairing (and implicitly *comparing*) the European discovery of the Pacific Ocean with a modern technological feat—completion of the Panama Canal—the exposition proudly announced San Francisco's sense of being at a historic juncture. For, with the canal's completion, the city seemed poised to dominate trade between Asia and the Americas.[9] That this economic exchange was seen in colonial terms, rather than as trade between equals, seems hinted at by the exposition's thematization of an Age of Exploration that set the stage for Europe's exploitation of the rest of the world. Thus, it is no surprise that a city whose economic future hinged on its Pacific Rim location chose to advertise its cultural sophistication by importing examples of European (and European-derived) modern art.

In scope, scale, and local impact, the resulting exhibition rivaled New York's 1913 Armory Show.[10] Although most of the more than eleven thousand works shown adhered to familiar academic formulas, "numerous examples of avantgarde . . . art, ranging from Post-Impressionism to Italian Futurism," were also displayed.[11] The aesthetic debates and social turmoil that spawned these stylistic revolts may have seemed remote or inscrutable to Pacific Slope artists at the time. But they were nonetheless galvanized by the new art's formal innovations, which they freely borrowed and promiscuously blended.[12] A cataclysmic event, the region's collective first encounter with European modern art altered the local artistic landscape, producing new alignments and unprecedented conjunctions. Thus, when a twenty-seven-year-old African-American migrant named Sargent Claude Johnson arrived in San Francisco, the Bay Area's art communities were experiencing the Big Bang that would launch their evolution of a modernism of their own.

An eclectic affair from the outset, Bay Area modernism developed within a larger, geographically determined social matrix that left more room for a figure like Johnson than East Coast cultural configurations did. Yet, he would not surface as an active participant in the local art scene until 1925. Several factors probably account for the ten-year delay. Although he is said to have initially tried his hand at sculpture during an adolescent stay with his aunt, the sculptor May Howard Jackson (1877–1931), and to have subsequently practiced modeling by copying tombstone figures while living with grandparents in Virginia, Johnson seems to have had no formal training in sculpture prior to his arrival in California. He had attended "a night-school course in drawing and painting" in Boston and quickly resumed classes in drawing and painting in the Bay Area.

But Johnson would not begin training in sculpture at the California School of Fine Arts (CSFA) until four years later.[13]

His marriage in 1915 and his daughter's birth in 1923 produced new financial responsibilities that probably curtailed his artistic activity. These vicissitudes at least partly explain Cedric Dover's description of Johnson in the 1920s as a creator of "exquisite *spare-time* works" (emphasis mine). But it must also be remembered that few Americans—married or single, parents or childless—could devote themselves exclusively to art making in the days before government patronage of the arts, least of all artists in the West. But there are indications that Johnson's dream of becoming an artist initially may have also been hampered by racial conditions in the Bay Area.

In a history of San Francisco's African-American population, Douglas Henry Daniels states that it "very possibly" may have been "more difficult for a Negro to obtain good employment in the Bay Area, especially in San Francisco, than in just about any major American city until World War II." Once the region's gold rush–era boom subsided, black San Franciscans had little chance of working as "skilled craftsmen or ordinary laborers, as these jobs were monopolized by whites." From 1860 to 1940, for Bay Area blacks, "[e]mployment in the service realm predominated."[14] Writing in 1912, W. E. B. DuBois observed that "on the whole a Negro mechanic is a rare thing" in the state of California.[15] Thus it is not entirely surprising that Johnson was employed as a framer (the period term *fitter* has caused some confusion as to what kind of work he did) beginning in 1917. But if Johnson's efforts to become an artist were initially hampered by race-based economic difficulties, the

artist he eventually became probably benefited in several ways from the unique position of African Americans in the Bay Area.

"In 1918, on the day an all-black army unit recruited from the East Bay left Oakland for World War I training, the city council passed an ordinance prohibiting blacks from buying property in the newly opened Santa Fe tract north of Forty-Seventh Street." The authors of a recent history of African-American life in the East Bay go on to explain that "the emergence of all-white residential areas" did not immediately produce "black ghettoes." Instead, in a pattern that had been typical of many United States cities prior to World War I but that persisted in the Bay Area until World War II, "the districts to which blacks were restricted were inhabited by multi-ethnic mixtures of middle- and working-class families and single people."[16] Across the bay in San Francisco, a wartime study by the eminent African-American sociologist Charles S. Johnson found "no rigidly segregated Negro community existed" until the 1940s. "Even along Fillmore Street," black San Franciscans "lived among Japanese, Chinese, Filipinos, and 'sizeable groups of whites'" throughout the 1930s.[17]

Thus, although they were not entirely exempt from housing discrimination, Bay Area blacks probably enjoyed a greater degree of residential integration than any other Afro–United States population in the interwar years. And because local demographics frequently supplied them with neighbors of Asian-Pacific origin, African Americans in the Bay Area were less apt than other blacks in the United States to view the world in binaristic, black-white terms. The unusual latitude in housing choices Bay Area blacks experienced suggests the existence of

comparatively fluid patterns of interaction between individuals of different races. Such conditions probably account for Johnson's acceptance into the local art establishment—as signaled by his election to the San Francisco Art Association in 1932 and to a seat on its Council Board in 1934, as well as his numerous stints on the sculpture jury for the association's annual exhibition—and his achievement of a status there that "no black artist in the East" had managed to attain since the nineteenth-century New England landscapist Edward Mitchell Bannister.[18] Above all, the combination of unparalleled access to local, dominant art circles and immersion in the region's relatively fluid, multicultural milieu allowed Johnson to synthesize material borrowed from a wide range of cultures, molding them into his own brand of Afro–United States modernism.

Johnson's 1927 portrait bust, *Elizabeth Gee* (PL. 2), demonstrates this convergence of stylistic eclecticism with multicultural experience. A relatively naturalistic work, at first glance the glazed stoneware child's bust seems either to reject or to retreat from modernist precedents in sculpture. *Elizabeth Gee* lacks the expressive surface of a Rodin or a Matisse, the planarity of a Gabo or an Archipenko, the radical simplification of a Modigliani or a Brancusi. Instead, Johnson's portrait declares its modern-ness through its use of color and choice of materials—both of which violate "high art" norms and embrace "decorative" properties.

This promiscuous mixing of modes is consistent with canonical modernism—with the paradoxical union of a utilitarian object (a cup) and its nonutilitarian treatment (its rendition in solid wood) seen in Brancusi's 1917 *Cup*, or the emulation of so-called naïve art by Elie Nadelman.

But it is also symptomatic of a distinctly "Bay Area" brand of stylistic eclecticism that took its cues from Asian and Meso-American artistic traditions, as well as from the democratic impulses of European modernism. Although the bust to which Johnson applies color is modeled in a relatively naturalistic style, he rejects the mimetic goals that led nineteenth-century sculptors from Charles-Henri Joseph Cordier to Max Klinger to polychrome sculpture. By conflating an elite genre—portraiture—with a commercial or "decorative" medium—glazed stoneware—Johnson closed the conventional gap between art and object in post-Renaissance Western aesthetics several decades before West Coast ceramic sculptors like Peter Voulkos and Robert Arneson.

From an early date then, Sargent Johnson was producing sculpture that reconfigured various hegemonic modernist tropes in a characteristically "San Francisco modernist" manner. But the regional specificity of this work is not a matter of style alone. Johnson's subject—a Chinese child whose family lived next door to the artist—also points to a key fact of Bay Area life. A long history of Asian presence and anti-Asian prejudice had ironically facilitated the preservation of Asian culture and identity, thus enabling a politically, socially, and economically marginalized group to exert a pervasive, if widely unrecognized, cultural influence. At the same time, African Americans represented a minuscule proportion of the Bay Area population and, as a result, enjoyed greater residential latitude there than anywhere else in the country. And, whereas whites clearly dominated the region, its geography, local demographics, and history produced a society in which difference did not gravitate exclusively around opposing poles of whiteness

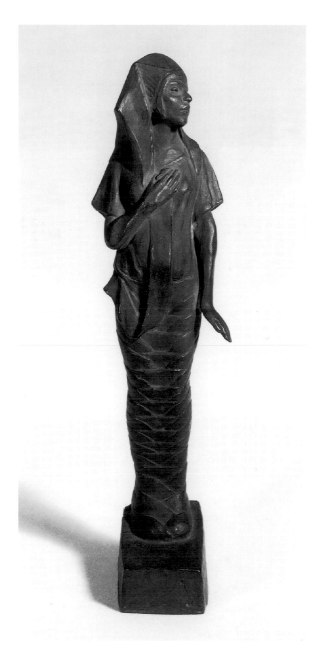

ly new talent was seen in the exquisite spare-time works, contemporary in feeling and entirely unclutttered by virtuosity, of Sargent Johnson."[19]

Artists who had reached maturity a decade before the 1920s Negro Renaissance, Meta Warrick Fuller (1877–1968) and May Howard Jackson were products of an earlier phase of African-American social and cultural history. Both natives of Philadelphia and members of that city's frequently light-skinned, black bourgeoisie, the two women's social origins reflect patterns that are familiar to students of African-American artistic activity during the preceding century and should be placed in a larger context of pre- and postbellum restriction of African-American artisanal activity.[20] Only gender distinguishes them from such figures as the photographers Jules Lion (ca. 1809/10–1866) and James P. Ball (1825–ca. 1904/5), the sculptor Eugene Warburg (ca. 1825–1859), or the painters Robert S. Duncanson (1821–1872), Edward Mitchell Bannister (1828–1901), and Henry Ossawa Tanner (1859–1937), each of whom enjoyed significant advantage over the majority of their black contemporaries, thanks to a combination of mixed ancestry, free and generally Northern birth, and concomitant access to education and skills denied most African Americans.[21] Like their Philadelphia predecessors, Robert Douglass and Tanner, as well as Pittsburgh native Alfred B. Stidum, Fuller and Jackson also profited from affiliations with the Pennsylvania Academy of the Fine Arts, one of the nation's top art schools.[22]

Ideologically, their sculpture projected the goals and assumptions of an early-twentieth-century Negro elite determined to "uplift" the less fortunate majority of their race. In works like her 1913 *Emancipation* group and 1915–21 *Ethiopia*

Fig. 12
Meta Warrick Fuller
Ethiopia Awakening
1915–21
Yale Collection of American Literature, Beinecke Rare Book and Manuscript Library, Yale University

and blackness. This seems to have opened a significant window of opportunity for Sargent Claude Johnson. Comparison with his eastern counterparts makes this clear. For, as Cedric Dover has observed: "Among the sculptors of the 'twenties, though Meta Fuller and May Jackson reached new heights and Richmond Barthé looked promising, the only evidence of a definite-

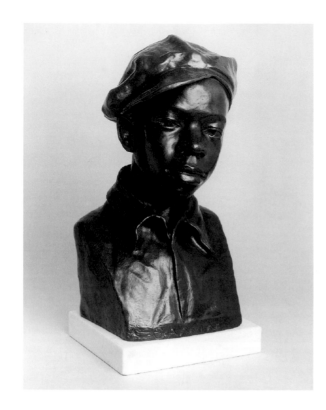

Fig. 13
Augusta Savage
Gamin
ca. 1930
Art and Artifacts
Division; Schomburg
Center for Research
in Black Culture;
The New York Public
Library; Astor,
Lenox, and Tilden
Foundations

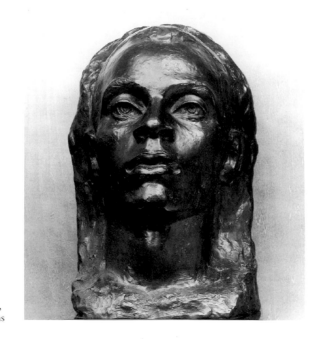

Fig. 14
Richmond Barthé
*The Negro Looks
Ahead*
1940
Art and Artifacts
Division; Schomburg
Center for Research
in Black Culture;
The New York Public
Library; Astor, Lenox,
and Tilden Foundations

Awakening (fig. 12), Fuller celebrated African-American history and promoted pride in African heritage, while Jackson advertised contemporary black achievement by sculpting portrait busts of figures such as the poet Paul Laurence Dunbar, the novelist Jean Toomer, the educator Kelly Miller, and the scholar-activist W. E. B. DuBois. It may be easy now to criticize their highbrow cultural mission, but in the face of a "crimson tide" of antiblack violence, a towering wall of legal repression, and widespread acceptance of demeaning racial stereotypes, asserting black dignity would have seemed radical. Notably lacking any appeal to white altruism or amusement, work like Fuller's and Jackson's announced the birth of a New Negro in the visual arts.[23] Thus, their sculpture can be linked thematically to an emergent modern black consciousness. But stylistically, both women remained wedded to the academic tradition in which they had been so thoroughly trained.

Among the artists who, like Sargent Johnson, emerged during the so-called Harlem Renaissance were three prominent sculptors: Elizabeth Prophet (1890–1960), Augusta Savage (1892–1962; fig. 13), and Richmond Barthé (1901–1989; fig. 14).[24] Prophet, who lived and worked in Paris from 1922 to 1934, seems to have been the most original of Johnson's black contemporaries. Although she sometimes balked at being labeled "a negro"—claiming her father's one-quarter Pequod-Narragansett ancestry as her full patrimony instead—during her years abroad she received the NAACP magazine *The Crisis* "on a regular basis" and corresponded with its editor, W. E. B. DuBois, about "black American achievements." In Paris, she occasionally visited Henry Ossawa Tanner, met the much-lionized Harlem Renaissance poet Countee Cullen, and welcomed

Augusta Savage, on her arrival in 1929.[25] Thus, she undoubtedly was aware of the cultural ferment in progress among African-American artists and intellectuals. That she shared their interest in redeeming the black visage from at least a century's worth of malign caricature and emulating the accomplishments of traditional African carvers is indicated by a letter to DuBois in which she reports on some of the African sculpture displayed at the 1931 Colonial Exposition and rhapsodically praises "heads that are [of?] such a mental development [as is?] rarely seen among Europeans. Heads of thought and reflection, types of great beauty and dignity of carriage. I believe it is the first time that this type of African has been brought to the attention of the world of modern times."[26]

Although her remarkable talent was recognized by such figures as Tanner and DuBois, Prophet's career was plagued by poverty, insufficient patronage, and emotional instability.[27] As a result, little of her work survives. Photographs of thirteen lost works, as well as four extant examples in public collections, show a preponderance of heads and busts, with only three full-figure statues.[28] Four carved wooden heads and two plaster busts appear to depict African or African-American subjects, with three—the wooden *Head of a Negro* (ca. 1926–27), the plaster bust of the same name (ca. 1925–29), and *Congolais* (ca. 1931)—identified as such.

After an initial period of technical groping, Prophet worked with equal fluency in wood, plaster, and stone. Her style blends an exquisite mastery of physiognomy and psychological nuance with an antinaturalistic emphasis on the artist's touch (especially visible in her wood carvings and plasters) and the tactile qualities of her

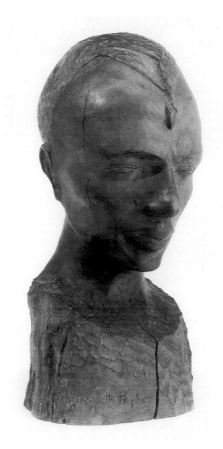

Fig. 15
Nancy Elizabeth Prophet
Congolais
ca. 1931
Collection of the Whitney Museum of American Art, New York

medium (most pronounced in her marble works). Balancing a high degree of naturalism and an idealizing semimuted treatment of detail, Prophet adheres to the moderate abstraction generally associated with turn-of-the-century Symbolism. "Progressive" in comparison with the work of Fuller and Jackson, Prophet's sculpture was considerably less innovative than Johnson's in both formal and thematic terms. Comparison of her best-known work, *Congolais* (fig. 15), of about 1931, with Johnson's contemporaneous *Chester* (PL. 5) makes this apparent.

Prophet's *Congolais* is an iconographic pastiche. Its title refers to Central Africa—today's People's Republic of the Congo and the Democratic Republic of Congo—while its one culturally specific visual element—a Masai warrior's plaited forelock—points to East Africa, the Masai's

Kenyan and Tanzanian home. Prophet was frequently unable to afford a model, and the schematic look of certain works suggests they were not sculpted from life. Although there is something abstract and lifeless about the artist's treatment of the eyes in *Congolais,* there is a close resemblance between the carving's facial features and Prophet's own. Thus, it seems likely that the head was carved from imagination, memory, or in front of a mirror—adding another layer of pastiche. While this sort of conflation of disparate sources, including the "real" and the "imaginary," is consistent with Symbolist aesthetics—think, for example, of Gauguin's 1889 *Christ in the Garden of Olives* (Norton Gallery of Art, West Palm Beach, Fla.), in which Jesus is given the artist's face—Symbolism itself was hardly *au courant* by the 1930s.

Johnson's *Chester,* however, is a work completely "of its time." Where Prophet carved a single block of cherry wood, leaving the area at the base of the neck rough so as to imply—in a Rodinesque manner—the form's emergence from the wood block and to reveal the artist's "touch," Johnson modeled a terracotta head and accompanying hand, each of which sprouts from spherical openings in the top of a cube-shaped wooden base that has been painted black. In its juxtaposition of truncated forms, *Chester* echoes the Dadaist/Cubist/Surrealist penchant for fragmentation and uncanny juxtapositions. While there is nothing inherently "uncanny" about a hand placed against the side of a face, the apparent "naturalness" of this conjunction is subtly undermined by the strangeness of body parts emerging from holes in a block of wood. Thus, Johnson eschews the conspicuous strangeness of Surrealism and its European modernist forerunners,

opting instead for an aesthetic balancing act in which the child's hand functions transitionally, its blunt contours echoing the work's rectilinear base, while its anatomical detail—though limited—seems to anticipate the fuller volumes of the face. For *Chester* participates in several other strains of modernism that were in circulation in 1931.

On the one hand, with its blunt digits and smooth, undifferentiated cap of hair, *Chester* resembles the work of a so-called naïve artist at a time when folk art was very much in vogue.[29] On the other, by uniting formal reductiveness with sensitive ethnic description, Johnson managed to fulfill Alain Locke's injunction to produce a truly "Negro" modern art—that is, one that synthesized "the lesson . . . of technical control" and "complete plastic freedom" embodied in African sculpture and conceived "Negro physiognomy . . . freshly and objectively . . . on its own patterns."[30]

The valorization of folk art was part of a widespread, interdisciplinary interest in United States folklife that inspired important studies of American folklore, as well as scholarly efforts to document and record "authentic" examples of folk music and museum acquisitions of traditional American crafts, which also became items of fashionable decor. At the same time, contemporary drama, literature, and film also demonstrated elite fascination with "the folk"—that is to say, with the ordinary, often poor, inhabitants of small towns and rural areas, people whose ways of life were thought to reflect the nation's regional diversity, on the one hand, and to embody "American" cultural essences, on the other. In the visual arts, this impulse underwrote a broad spectrum of nativist tendencies—rang-

ing from the stylistic conservativism of Regional-
ists like Thomas Hart Benton and Grant Wood
to the figurative expressionism of Marsden Hart-
ley and the precisionism of Charles Sheeler.

Insofar as it reflected a parallel interest in
locating cultural essences unique to American
black life, the dream of an African-American
modernism articulated by Locke and others was
a by-product of this upsurge of cultural nation-
alism. But any ostensible parity between the
African-American and Euro-American mod-
ernist projects is belied by an underlying concep-
tual problem: the international character of
black "nationalism"—that is to say, the cruci-
ality of African heritage to most theories of black
cultural difference.[31] Locke's emphasis on the
formal potential of African art for African-
American modernism obliquely references this
problem, which had previously been articulated
in thematic terms by cultural theorists such as
DuBois and by Locke himself. And, as we have
seen, at least one artist of the prior generation—
Meta Fuller—had taken on this challenge in
iconographic terms.

Among the painters and sculptors of the
Negro Renaissance, both African heritage in
general and African art in particular were often
addressed thematically.[32] Indeed, this can be
identified as a key trope that distinguishes this
generation's art from the bulk of its predeces-
sors'. Work that took its *stylistic* cues from
African sources was much less common, howev-
er.[33] Among the major sculptors, only Sargent
Johnson produced objects that exhibit African
style traits—ranging from the masklike styliza-
tion of his faces and his use of polychrome to the
head-to-body ratio of the female figure and the
hieratic proportion of the children's bodies in

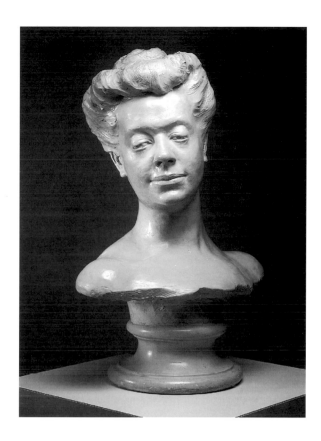

Fig. 16
May Howard Jackson
Bust of a Woman
n.d.
Collection of the
Howard University
Gallery of Art,
Washington, D.C.

relation to the mother's in *Forever Free* (PL. 8).[34]
And in doing so, Johnson successfully resolved
the national/international (or local/transatlantic)
dichotomy embedded in Locke's prescription.

Johnson's forerunners, from James P. Ball
and Robert Douglass on, had recognized the
importance of redeeming the black image—that
is, rescuing it from cruel caricature via accurate
description.[35] It seems likely that Johnson's
desire "to show the natural beauty and dignity in
that characteristic lip, that characteristic hair,
bearing and manner" of "the pure American
Negro" stemmed from a variety of sources,
including Negro Renaissance cultural agendas.[36]
But at least two biographical sources also suggest
themselves. On the one hand, the hardships
resulting from his parents' interracial marriage
and the estrangements of several of his siblings,

who chose to "pass," provided strong psychological motives for celebrating the visible signs of blackness he himself lacked.[37] On the other, during his adolescent stay with his aunt, May Howard Jackson, he is likely to have been exposed to her views on the subject.

Like Johnson, Jackson was extremely fair-skinned and probably was frequently mistaken for white, producing an inconsistent experience of race-based exclusion that can be more jarring than a life in which such exclusion is predictably routine and, hence, to a degree, taken for granted. On her death in 1931, she was described by W. E. B. DuBois as "bitter and fierce," a woman whose soul was "tor[n] asunder" by "the contradictions and idiotic ramifications of the Color Line."[38] In his pioneer history of African-American art, Alain Locke hailed her as "the first [Negro artist] to break away from academic cosmopolitanism [and move] to frank and deliberate racialism. May Howard Jackson," he continued, "was always intrigued by Negro types, their puzzling variety and distinctive traits."[39] Unlike her nephew though, Jackson did not focus on the predominantly African-seeming or "pure" American Negro. Instead, her interest centered on precisely the "culturally mixed" urban type that Johnson eschewed (fig. 16).[40] Although such an orientation was novel at the time and apparently earned her considerable opprobrium, it strikes us now as per-

fectly consistent with the genteel preoccupations of the early-twentieth-century "Talented Tenth" to which Jackson belonged, whereas Johnson's statement that "[t]he slogan for the Negro artist should be 'go South, young man' " is equally redolent of the interests in regionalism, unspoiled "folk" enclaves, and ethnocultural essentialism that characterize the period in which he came to the fore.[41]

Given the centrality of these issues to Negro Renaissance thought and their wide currency in the dominant culture, it seems strange that none of the African-American artists clustered in East Coast centers like New York, Washington, or Philadelphia arrived at an equally compelling solution to the problems posed by Locke's prescription for an African-American modernism. In outlining the various conjunctions of Bay Area art history and Johnson's personal preoccupations, Bay Area ethnocultural configurations and their ostensible effects on his work, as well as the main features of the development of early-twentieth-century African-American sculpture and the character of Johnson's achievement in that regard, I hope to have suggested some of the ways that his unique position within a series of overlapping artistic and social landscapes probably conditioned Sargent Johnson's unique approach to the problem of Afro-American modernism.

Notes

1. As Richard Cándida Smith has observed, modernism is relational in two senses. On the one hand, it has functioned comparatively through its nostalgic evocation of a "classic age one has missed." On the other, because artists' "responses to the simultaneous expansion of knowledge and imagination [triggered by the scientific/technical revolution] varied across time, place, and position," the development of modernism was uneven and must be viewed relatively. Richard Cándida Smith, "The Elusive Quest of the Moderns," in *On the Edge of America: California Modernist Art, 1900–1950,* ed. Paul J. Karlstrom (Berkeley and Los Angeles: University of California Press, 1996), p. 34.

2. Elizabeth Parker, "A Walking Tour of Black San Francisco," in *Our Roots Run Deep, Volume One: The Black Experience in California, 1500–1900,* ed. John William Templeton (San Jose, Calif.: Electron Access, 1991), pp. 330–31, 336, 338–39, 341.

 That Johnson was not the only resident black artist but the only one to gain recognition in California at the time is asserted by the (only) black *Oakland Tribune* columnist Delilah Beasley in a 1933 Harmon Foundation exhibition catalogue: *Exhibition of Productions by Negro Artists,* exh. pamphlet (New York: The Harmon Foundation, 1933), p. 17.

3. Romare Bearden and Harry Henderson, *A History of African-American Artists, from 1792 to the Present* (New York: Pantheon, 1993), p. 219.

4. According to Beasley, a canvas by a contemporary African-American painter named Eugene Alexander Burkes had been offered to the Oakland Municipal Art Gallery for its permanent collection. Beasley also cites the Los Angeles resident Julian C. Robinson and the Oakland ceramicist and illustrator Eleanor E. Paul among "Negro artists and art students . . . scattered all over the Western states" whose "shyness" hampered professional recognition. Beasley paraphrased in 1933 Harmon pamphlet, p. 17.

5. Noting that Johnson's *Sammy* "showed him already committed in 1928 to a strongly simplified style," Alain Locke declared, "he has come to reflect more than any other contemporary Negro sculptor the modernist mode and the African influence." Writing about a 1934 traveling exhibition of work by African-American artists that was cosponsored by the Harmon Foundation and the College Art Association, Rose Henderson observed that "while Negro subjects predominated, the treatment, with the exception of Sargent Johnson's work, was not essentially racial." Alain LeRoy Locke, *Negro Art: Past and Present* (1936; Salem, N.H.: Ayer Company Publishers, 1991), p. 78. Henderson, "Negro Art Exhibit," *Southern Workman* 63, no. 7 (July 1934): 217.

6. In a 1935 interview in the *San Francisco Chronicle,* Johnson claimed to be "producing a strictly Negro art." "San Francisco Artists," *San Francisco Chronicle,* October 6, 1935, p. D3.

7. Terry St. John, "California Painting and Sculpture from 1915 to 1960," in *The Art of California: Selected Works from the Collection of the Oakland Museum,* ed. Christina Orr-Cahall (Oakland: The Oakland Museum; San Francisco: Chronicle Books, 1984), p. 20.

8. Thomas Albright, *Art in the San Francisco Bay Area, 1945–1980: An Illustrated History* (Berkeley and Los Angeles: University of California Press, 1985), p. 1.

9. Henry T. Hopkins, *Painting and Sculpture in California: The Modern Era,* exh. cat. (San Francisco: San Francisco Museum of Modern Art, 1976), p. 21.

10. Hopkins, *Painting and Sculpture in California,* pp. 22–24.

11. St. John, "California Painting and Sculpture," p. 20.

12. Albright, *Art in the San Francisco Bay Area,* pp. 2–4. Hopkins, *Painting and Sculpture in California,* pp. 22–24.

13. Bearden and Henderson, *A History of African-American Artists,* pp. 216, 217.

14. Daniels writes that the Bay Area "offered Afro-Americans the same kinds of jobs in 1910 and 1930 as in 1860," with 48 percent of black men and 70 percent of black women engaged in service work in 1910, while employment statistics for 1930 show 51 percent of black men and 89 percent of black women at work "in the service sector of San Francisco's economy." The situation was the same in Oakland from 1900 to the beginning of

World War II. Douglas Henry Daniels, *Pioneer Urbanites: A Social and Cultural History of Black San Francisco* (Philadelphia: Temple University Press, 1980), pp. 17, 31–32.

15. DuBois, *The American Negro Artisan* (1912), cited in Daniels, ibid., p. 34 n. 39. As Daniels points out, this situation reflects an ironic feature of San Francisco's historic liberalism, which empowered labor unions that practiced racial discrimination, systematically barring blacks and the Chinese from membership. As a result, from 1880 to 1920, African Americans were largely excluded from industry and the skilled trades. A wave of government-inspired anti-communist hysteria and a rash of pro-labor bombings temporarily broke labor's grip, however, and "an open shop policy prevailed in San Francisco" during the 1920s. Although this produced a marked increase in industrial jobs for local blacks, there does not seem to have been a corresponding rise in opportunities for black artisans. Daniels, ibid., pp. 17, 27, 34, 42.

16. Lawrence P. Crouchett, Lonnie G. Bunch III, and Martha Kendall Winnacker, *Visions toward Tomorrow: The History of the East Bay Afro-American Community, 1852–1977* (Oakland: The Northern California Center for Afro-American History and Life, 1989), pp. 21–22.

17. Charles S. Johnson, *The Negro War Worker in San Francisco: A Local Self-Survey* (1944), p. 3, quoted in and paraphrased by Daniels, *Pioneer Urbanites*, p. 99.

18. Bearden and Henderson also cite Johnson's eventual promotion to unit supervisor on California's WPA art project "without the struggle required in the East and elsewhere to win such posts for African-American artists." Bearden and Henderson, *A History of African-American Artists*, pp. 219–21.

19. Cedric Dover, *American Negro Art* (1960; Greenwich, Conn.: New York Graphic Society, 1970), p. 35.

20. John Hope Franklin, *From Slavery to Freedom: A History of Negro Americans*, 3d ed. (New York: Vintage, 1969), pp. 222–23, 312–13.

21. Of these artists, only Lion, Ball, and Warburg were not Northern-born. Lion was born and raised in France, Ball in Virginia, and Warburg in New Orleans. As *gens de couleur libre*, Lion (a New Orleans resident from 1836 or 1837) and Warburg belonged to the most economically and socially privileged group of people of African descent in the antebellum United States. Ball is the only one of these artists who might have been born a slave. Patricia Brady, "A Mixed Palette: Free Artists of Color of Antebellum New Orleans," *International Review of African American Art* 12, no. 3 (1995): 5–14, 53–57. Deborah Willis, *J. P. Ball: Daguerrean and Studio Photographer* (New York: Garland, 1993), pp. xiv–xix. Joseph D. Ketner, *The Emergence of the African-American Artist, 1821–1872* (Columbia: University of Missouri Press, 1993), pp. 2, 11–13. Juanita Marie Holland, "Reaching through the Veil: African-American Artist Edward Mitchell Bannister," in *Edward Mitchell Bannister, 1828–1901,* exh. cat. (New York: Kenkeleba House and Harry N. Abrams, 1992), p. 17.

22. Robert Douglass participated in the academy's 1876 and 1878 annuals and is thought to have received some private instruction from Philadelphia's leading portrait painter, Thomas Sully, a member of the academy's faculty. Tanner studied with Thomas Eakins at the academy intermittently from 1879 through 1885. Stidum studied at the academy 1880–83. May Howard attended the academy from 1895 through 1898 and 1900 to 1902. Having already spent 1896–99 at the Pennsylvania Museum and School of Industrial Art and trained at the Ecole des Beaux-Arts and Académie Colarossi in Paris during 1899–1902, Meta Warrick took classes with the sculptor Charles Grafly at the Pennsylvania Academy in 1906–7. Steven Loring Jones, "A Keen Sense of the Artistic: African American Material Culture in Nineteenth-Century Philadelphia," *International Review of African American Art* 12, no. 2 (1995): 11, 22, 23, 27 n. 57. Dewey F. Mosby, "Student Years and Early Career, 1873–1890," in *Henry Ossawa Tanner,* exh. cat. (Philadelphia: Philadelphia Museum of Art, 1991), pp. 59–60. Kathleen James and Sylvia Yount, "Chronology," in *Henry Ossawa Tanner,* p. 36. Tritobia Hayes Benjamin, "May Howard Jackson and Meta Warrick Fuller: Philadelphia Trail Blazers," in *Three Generations of African-American Women Sculptors: A Study in*

Paradox, exh. cat. (Philadelphia: The Afro-American Historical and Cultural Museum, 1996), pp. 20, 21, and n. 10. Judith Nina Kerr, "God-Given Work: The Life and Times of Sculptor Meta Vaux Warrick Fuller" (Ph.D. diss., University of Massachusetts, Amherst, 1986), pp. 46, 66, 68, 141.

23. Periodizing the phenomenon of the "New Negro" is problematic, given the enormous disparities between and gaps in existing accounts. For example, Henry Louis Gates, Jr.'s, well-known essay "The Face and Voice of Blackness" dates "the creation of the New Negro" to the years 1895–1925, ostensibly because this was a period of unprecedented literary production. Yet, he phrases this in a way that also alludes to important sociopolitical factors ("Between 1895 and 1925, at the height of racially inspired violence towards African-Americans, . . . black writers published at least 64 novels") without detailing their nature or pursuing questions of historical agency. In contrast, Ernest Allen, Jr., targets a narrower slice of the same period in his essay "The New Negro: Explorations in Identity and Social Consciousness, 1910–1922," but outlines specific political, social, and historical conditions he feels account for the rise of a "New Negro movement." The incongruence of accounts such as Allen's and Gates's suggests the need for a thorough reexamination of the whole subject. Gates, "The Face and Voice of Blackness," in *Facing History: The Black Image in American Art, 1710–1940,* ed. Guy C. McElroy, exh. cat. (San Francisco: Bedford Arts; Washington, D.C.: The Corcoran Gallery of Art, 1990), p. xxxiii. Ernest Allen, Jr., "The New Negro: Explorations in Identity and Social Consciousness, 1910–1922," in *1915, the Cultural Moment: The New Politics, the New Woman, the New Psychology, the New Art, and the New Theatre in America,* ed. Adele Heller and Lois Rudnick (New Brunswick, N.J.: Rutgers University Press, 1991), pp. 48, 49, 50–62.

24. Lynn Moody Igoe, *250 Years of Afro-American Art: An Annotated Bibliography* (New York: R. R. Bowker, 1981), p. 1039. Juanita Marie Holland, "Augusta Christine Savage: A Chronology of Her Art and Life, 1892–1962," in *Augusta Savage and the Art Schools of Harlem,* exh. cat. (New York: The Schomburg Center for Research in Black Culture, the New York Public Library, 1988), pp. 12, 19. Judith Wilson, "Art," in *Black Arts Annual, 1988–89,* ed. Donald Bogle (New York: Garland, 1990), p. 55.

25. Dover, *American Negro Art,* p. 56. Theresa Leininger, "Elizabeth Prophet (1890–1960): Sculptor, Educator," in *Notable Black American Women,* ed. Jessie Carney Smith (Detroit: Gale Research, 1991), pp. 890, 893. Blossom S. Kirschenbaum, "Nancy Elizabeth Prophet, Sculptor," *Sage: A Scholarly Journal on Black Women* 4, no. 1 (Spring 1987): 46.

26. Elizabeth Prophet to W. E. B. DuBois, August 20, 1931, quoted in Leininger, "Prophet," p. 896.

27. In a 1928 letter of recommendation, Tanner wrote: "Of the many, many students over here either white or black I know of none with such promise as Mrs. Prophet." Leininger, "Prophet," pp. 892–93.

DuBois, in a March 14, 1940, letter to the photographer Alexander Alland, tersely compared Prophet and Savage: "Augusta Savage is a hard working artisan but scarcely a first class sculptor. Our greatest Negro sculptor is Elizabeth Prophet." DuBois, "Letter to Mr. Alexander Alland, Atlanta, Ga., March 14, 1940," in *The Correspondence of W. E. B. DuBois, Vol. II: Selections, 1934–1944,* ed. Herbert Aptheker (Amherst: University of Massachusetts Press, 1976), p. 221.

28. For the thirteen lost works, see photographs from the Carl Russell Gross Papers (1888–1971), Special Collections, Adams Library, Rhode Island College, Providence, reproduced in Theresa Leininger-Miller, "African-American Artists in Paris, 1922–1934," vol. 3, Illustrations (Ph.D. diss., Yale University, 1995), pp. 417–21, 424–28, 430–33. Three of the four works in public collections are located in the Museum of Art, Rhode Island School of Design. The third is in the Whitney Museum of American Art. They are reproduced in Leininger-Miller, pp. 416, 422–23, 429, 434.

29. Judith Stein, "An American Original," in *I Tell My Heart: The Art of Horace Pippin,* exh. cat. (Philadelphia: Pennsylvania Academy of the Fine Arts; New York: Rizzoli, 1993), pp. 2, 12.

30. Alain LeRoy Locke, "The Legacy of the Ancestral Arts," in *The New Negro* (1925; reprint, New York: Atheneum, 1968), pp. 256, 260, 264.

31. The principal exception would be theories that make slavery and its legacy of social disadvantage the sole source of black difference, arguing or implying that the depradations of bondage erased all cultural traces of an African past among African Americans.

32. Well-known examples include Archibald Motley's *Kikuyu God of Fire* (1927), reproduced in Jontyle Theresa Robinson and Wendy Greenhouse, *The Art of Archibald J. Motley, Jr.,* exh. cat. (Chicago: Chicago Historical Society, 1991), p. 81; Elizabeth Prophet's previously discussed carving, *Congolais;* Malvin Gray Johnson's *Self-Portrait* (1932), reproduced in Gary A. Reynolds and Beryl J. Wright, *Against the Odds: African-American Artists and the Harmon Foundation,* exh. cat. (Newark: The Newark Museum, 1990), p. 208; Lois Mailou Jones's canvas *The Ascent of Ethiopia* (1932), reproduced in Alvia J. Wordlaw, *Black Art Ancestral Legacy: The African Impulses in African-American Art,* exh. cat. (Dallas: Dallas Museum of Art, 1989), p. 159; Palmer Hayden's still life *Fétiche et fleurs* (ca. 1932–33), reproduced in Allan M. Gordon, *Echoes of Our Past: The Narrative Artistry of Palmer C. Hayden,* exh. cat. (Los Angeles: The Museum of African American Art, 1988), p. 34; the first panel of Aaron Douglas's *Aspects of Negro Life* (1934) mural cycle, reproduced in Amy Helene Kirschke, *Aaron Douglas: Art, Race, and the Harlem Renaissance* (Jackson: University Press of Mississippi, 1995), pl. 79, after p. 76; and Richmond Barthé's bronze statue *Feral Benga* (1935), reproduced in Reynolds and Wright, *Against the Odds,* p. 122, pl. II.

33. The painter Hale Woodruff managed to do so by cannily conflating references to Cézanne, Cubism, and Fang white-faced masks in his *Card Players* (1929–30), reproduced in Alain LeRoy Locke, *The Negro in Art: A Pictorial Record of the Negro Artist and of the Negro Theme in Art* (1940; New York: Hacker Art Books, 1979), p. 54, and similar intent can be ascribed to Malvin Gray Johnson's placement of a pair of (presumably) African masks in the background of a self-portrait rendered in Cubist perspective.

34. The ratio of the head to the overall body of the female figure is approximately 1:5. In sub-Saharan African sculpture, head-to-body proportions of 1:3 and 1:4 are most common, in comparison with European proportions of 1:7 or 1:8. The 1:5 ratio is also found in sub-Saharan African sculpture, though less frequently than 1:3 or 1:4. Jan Vansina, *Art History in Africa: An Introduction to Method* (New York: Longman, 1984), pp. 84–85. I interpret the proportions of the mother and children in *Forever Free* as "hieratic" because the children seem both too large for their apparent ages (thus, their size does not correspond to Western naturalistic proportions) and sufficiently small in comparison with the mother to signal their status in relation to her. Among the most famous African examples of this gauging of size according to status (i.e., "hieratic proportions") are the multifigured metal plaques from the court of Benin, which Johnson is likely to have known.

35. Jones, "A Keen Sense of the Artistic," pp. 10–15.

36. Johnson quoted in *San Francisco Chronicle,* October 6, 1935.

37. Bearden and Henderson, *A History of African-American Artists,* pp. 216, 217.

This need to validate what was most problematic in his own individual and his family's history—his African-derived or "pure American Negro" identity—would also explain Johnson's otherwise anomalous preference for "studying not the culturally mixed Negro of the cities, but the more primitive slave type." Johnson quoted in *San Francisco Chronicle,* October 6, 1935.

38. DuBois, *The Crisis* (October 1931), p. 351, quoted in Benjamin, "Jackson and Fuller," p. 21.

39. Locke, *Negro Art,* pp. 30–31.

40. Locke, ibid., p. 31, quotes an unnamed "critic"'s remarks about this aspect of Jackson's portraiture: "The composite group of American Negroes has not yet been recognized as a people in whom intellect as well as sensuality exists in a variety of interesting forms. This is the new field to which she had dedicated an original and experimenting talent."

41. *Talented Tenth* was DuBois's term for an educated, African-American leadership class. W. E. B. DuBois, *The Souls of Black Folk* (1903; Greenwich, Conn.: Fawcett, 1961), pp. 84–85. Johnson quoted in *San Francisco Chronicle,* October 6, 1935.

PLATES

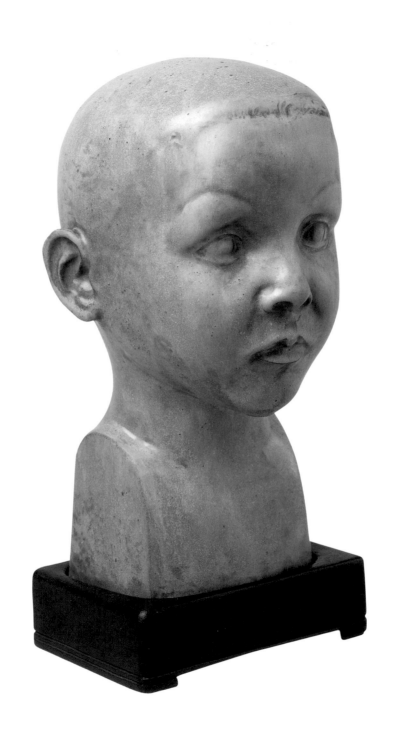

1. Untitled, 1927
Cat. No. 3

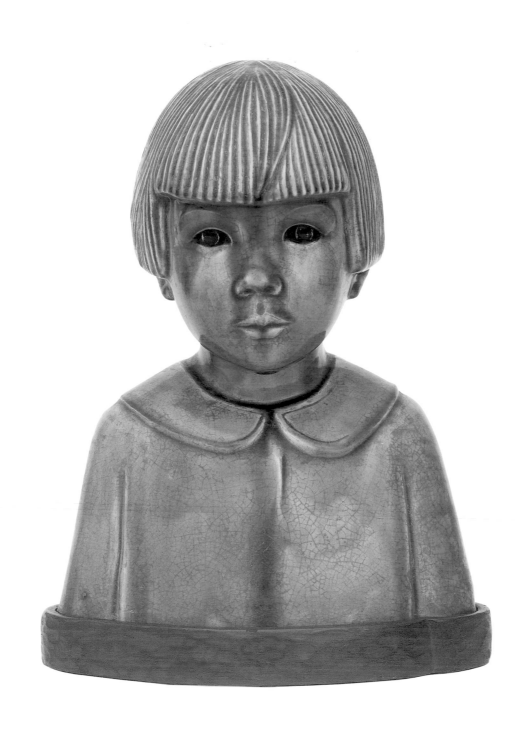

2. Elizabeth Gee, 1927
Cat. No. 2

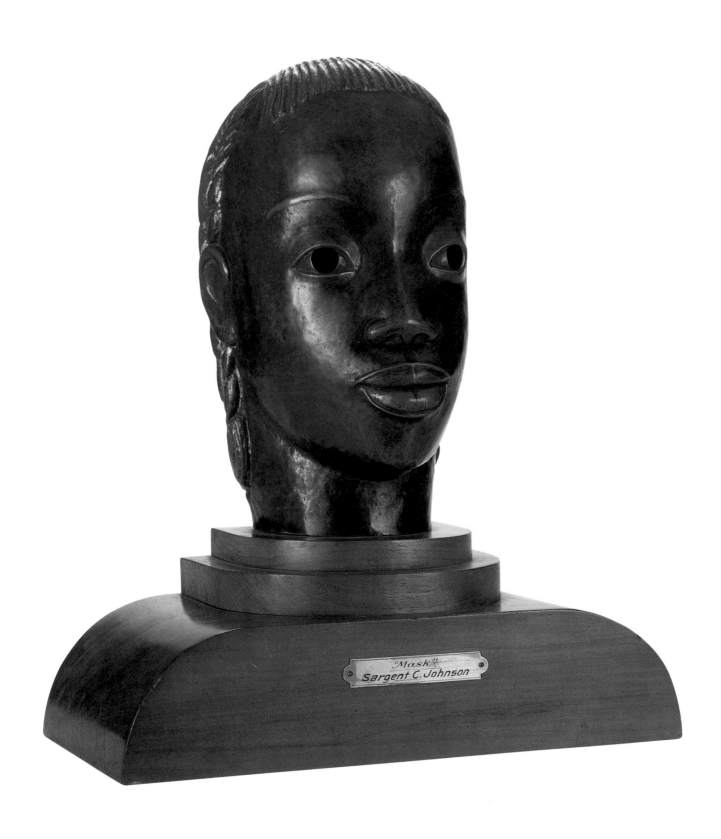

3. *Mask*, ca. 1930–35
Cat. No. 5

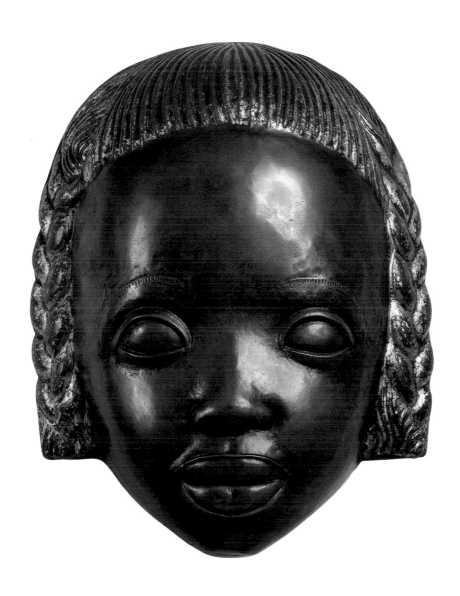

4. *Mask of a Girl*, 1926
Cat. No. 1

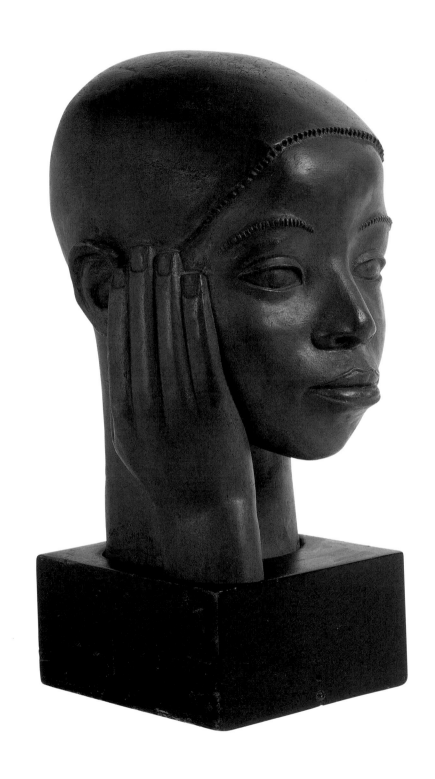

5. *Chester*, 1931
Cat. No. 6

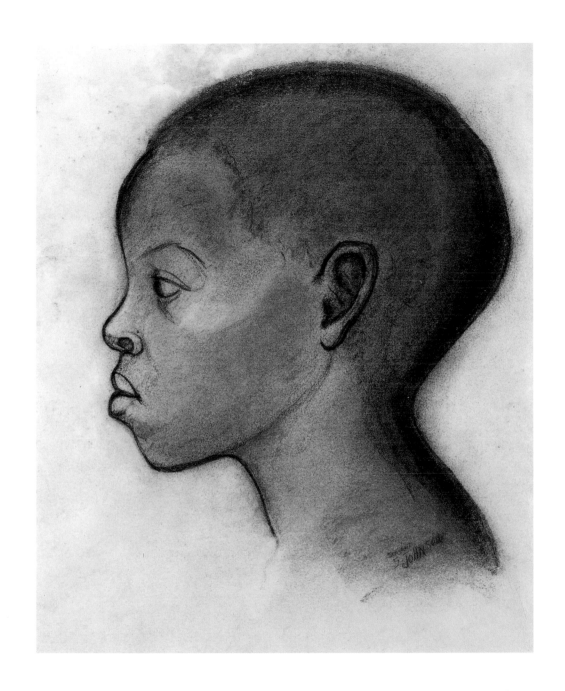

6. *Head of a Boy,* ca. 1931
Cat. No. 7

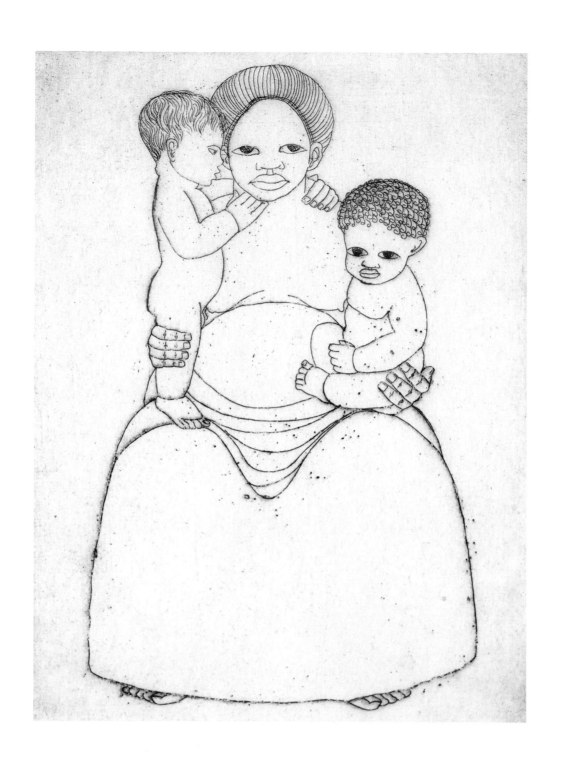

7. *Divine Love*, 1935
Cat. No. 13

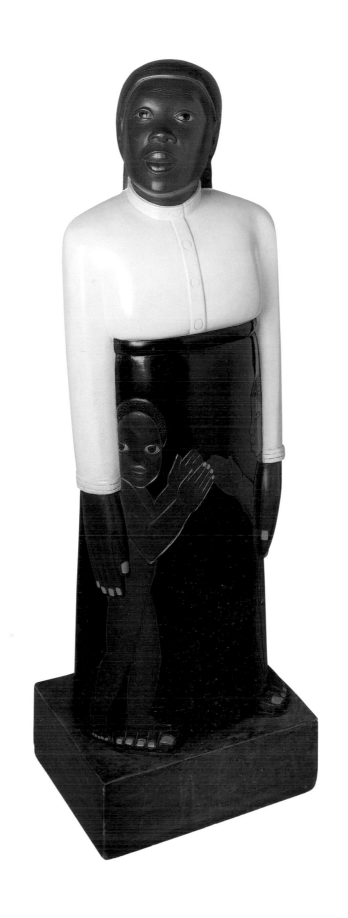

8. *Forever Free*, 1933
Cat. No. 8

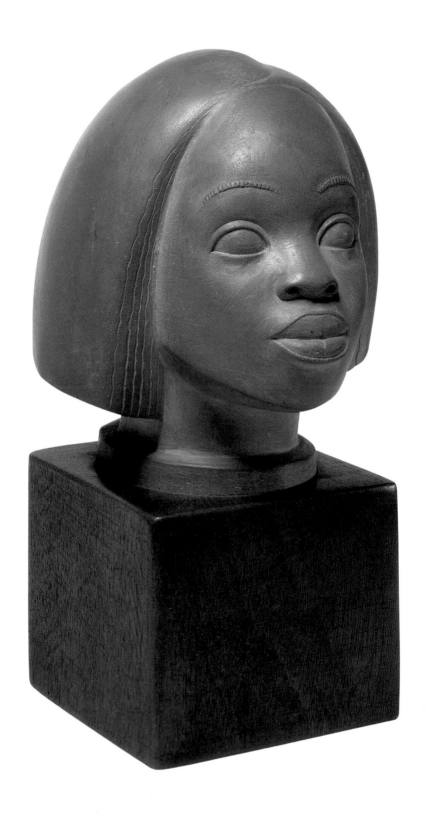

9. Negro Woman, 1933
Cat. No. 10

10. *Mask*, 1933
Cat. No. 9

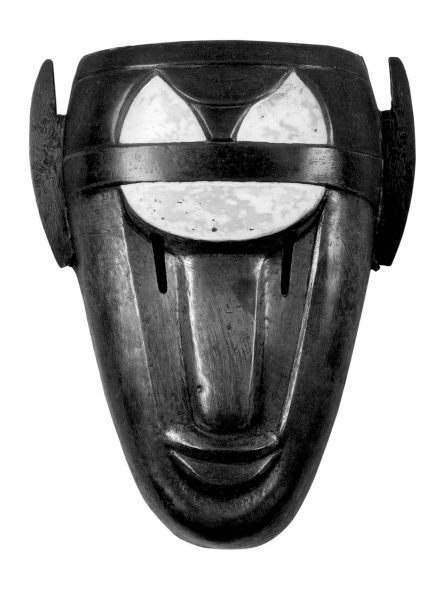

11. *Mask,* ca. 1934
Cat. No. 12

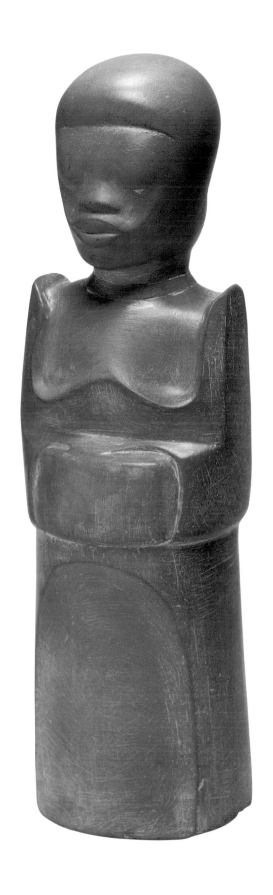

12. *Standing Woman*, 1934
Cat. No. 11

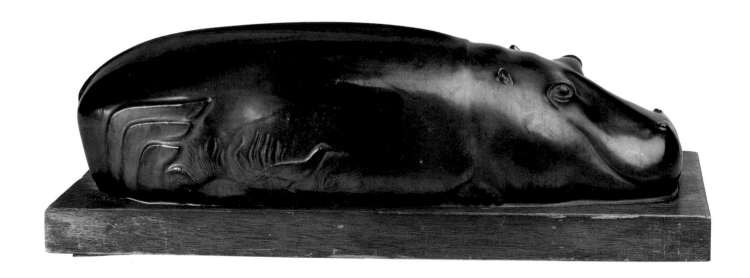

13. *Hippopotamus*, 1939
Cat. No. 22

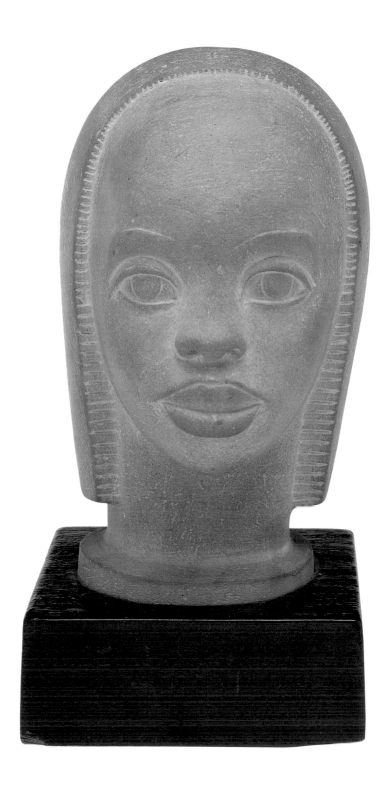

14. *Head of a Negro Woman*, ca. 1935
Cat. No. 16

15. *Dorothy C.*, ca. 1938
Cat. No. 20

16. *Lenox Avenue*, 1938
Cat. No. 19

17. *Singing Saints*, 1940
 Cat. No. 24

18. *Singing Saints,* 1966–67
Cat. No. 55

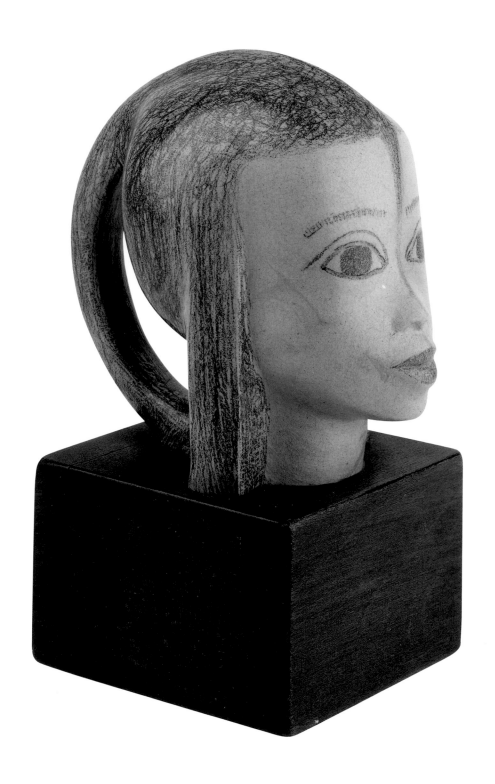

19. *Female Egyptian Head*, ca. 1940
Cat. No. 25

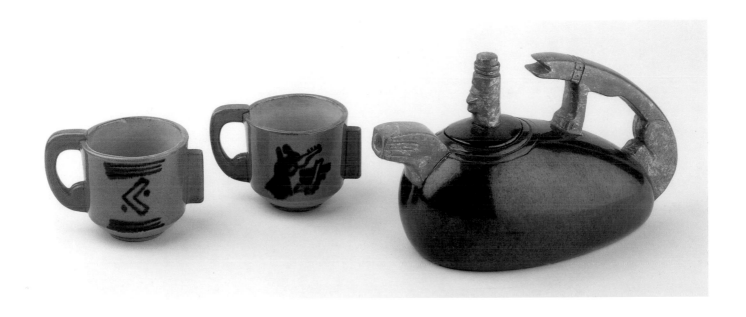

20. *Teapot and Two Cups*, 1941
Cat. No. 28

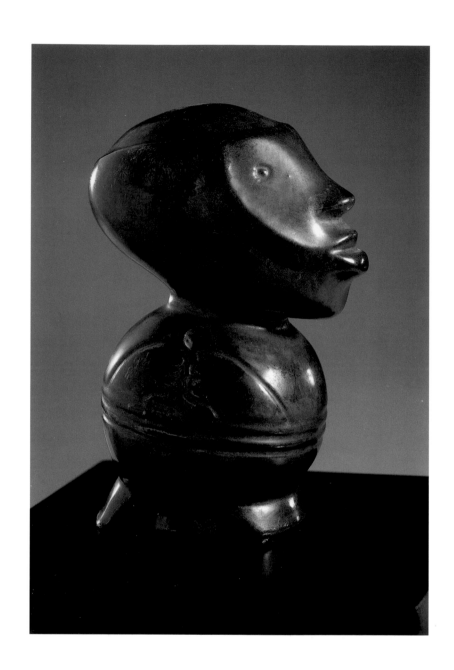

21. *Primitive Head*, 1945
Cat. No. 33

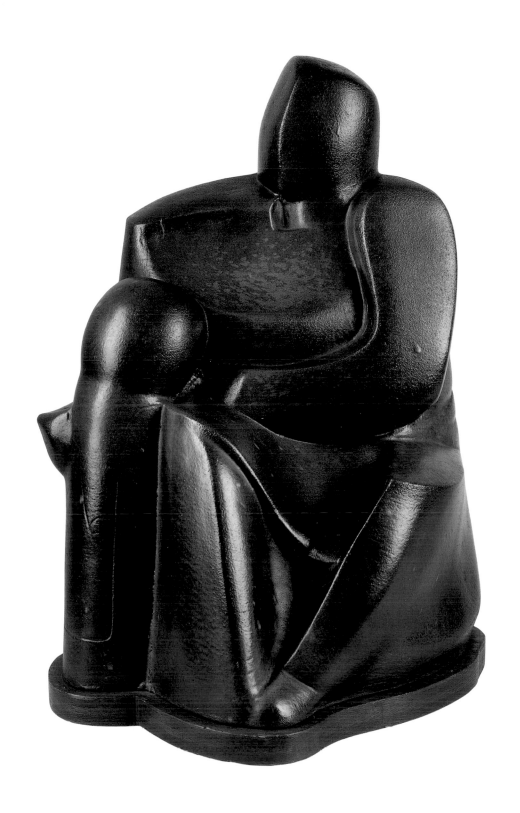

22. *Mother and Child*, 1947
Cat. No. 37

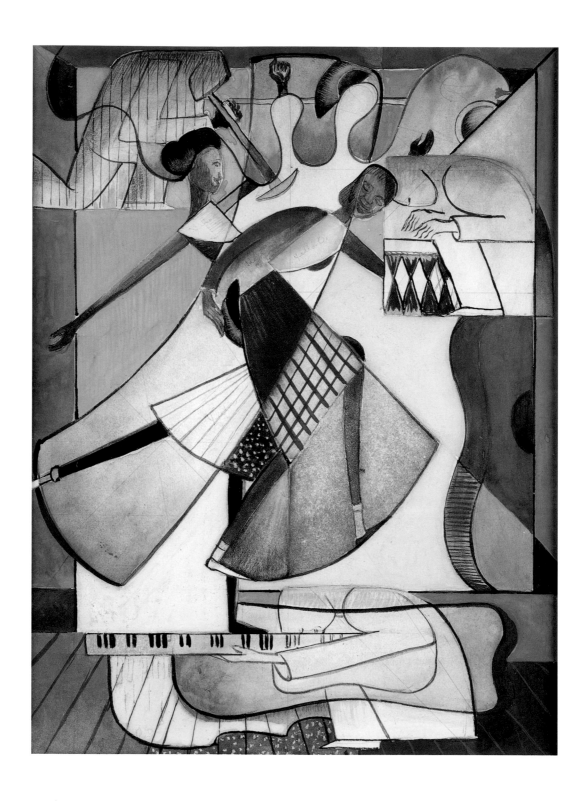

23. *Dance Hall*, ca. 1950
 Cat. No. 41

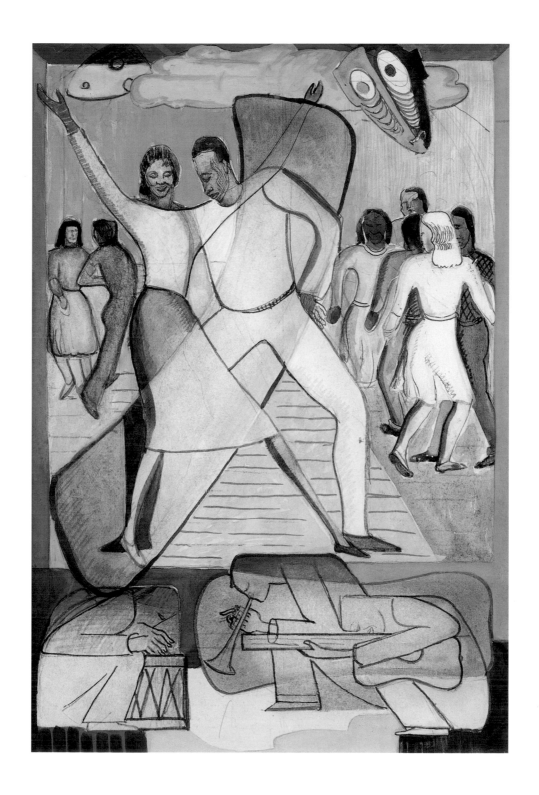

24. *Dance Hall*, ca. 1950
Cat. No. 42

25. *The Knot and the Noose*, 1948
 Cat. No. 39

26. Untitled, 1957
Cat. No. 45

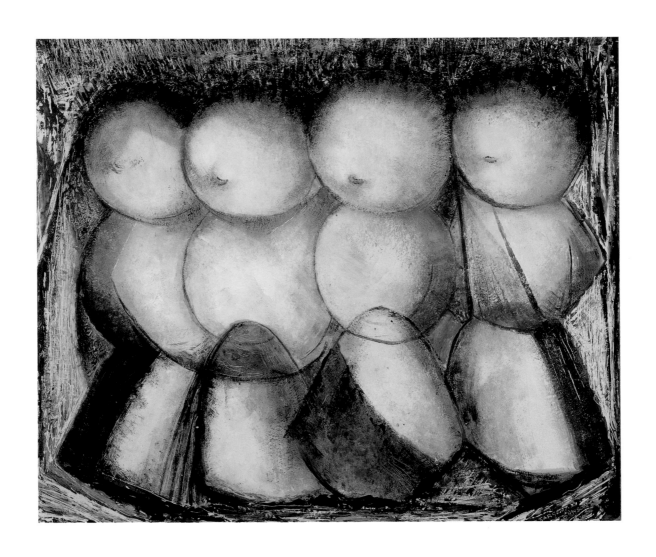

27. *The Four Sisters*, 1963
 Cat. No. 48

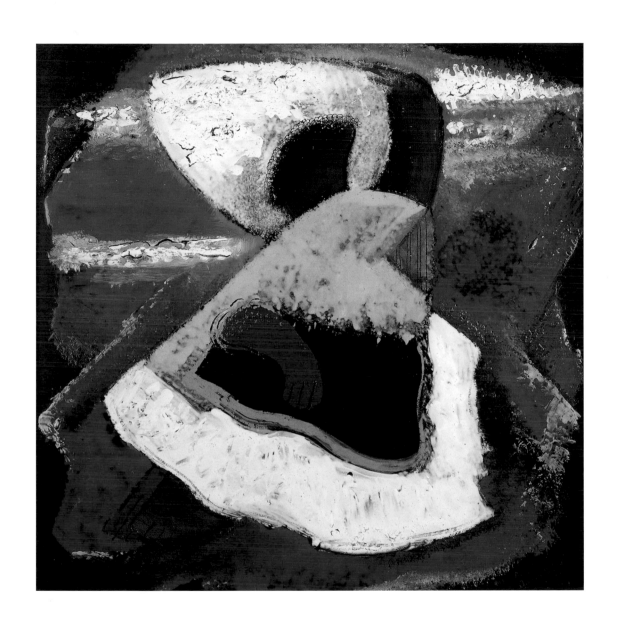

28. *By the Seashore*, 1948
Cat. No. 38

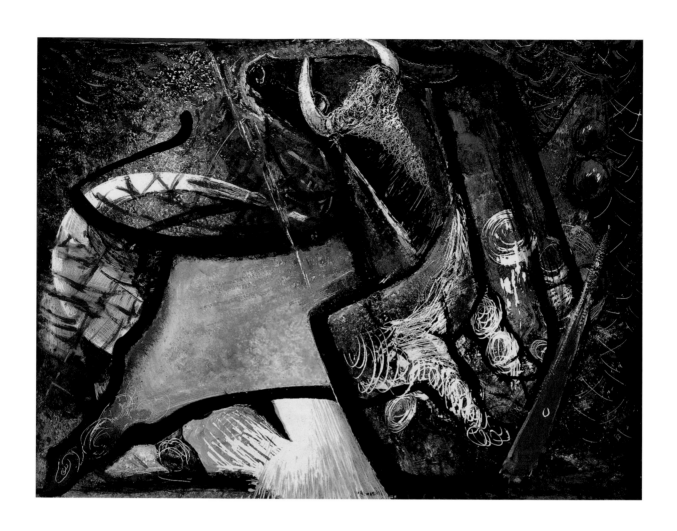

29. *The Bull*, ca. 1960
Cat. No. 46

30. *Rape,* ca. 1960
(front view)
Cat. No. 47

31. *Rape,* ca. 1960
(back view)
Cat. No. 47

32. *Moses*, ca. 1950
Cat. No. 43

33. *Girl with Braids*, 1964
Cat. No. 49

34. *Mother and Child*, 1965
Cat. No. 50

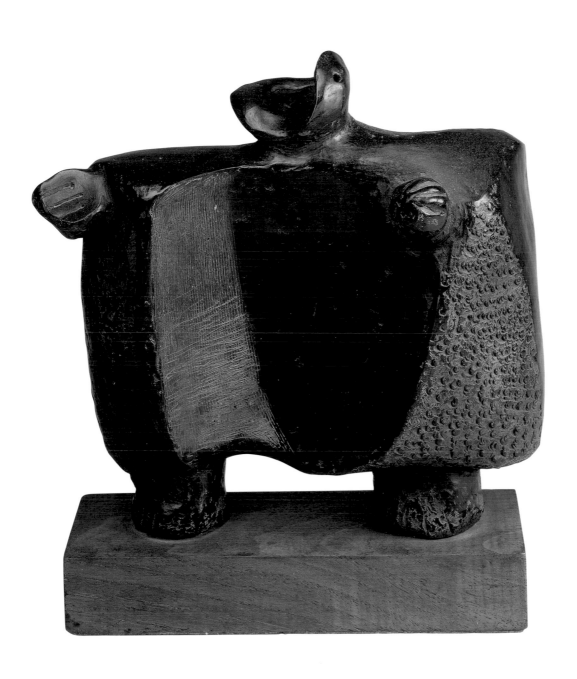

35. *The Politician*, 1965
Cat. No. 51

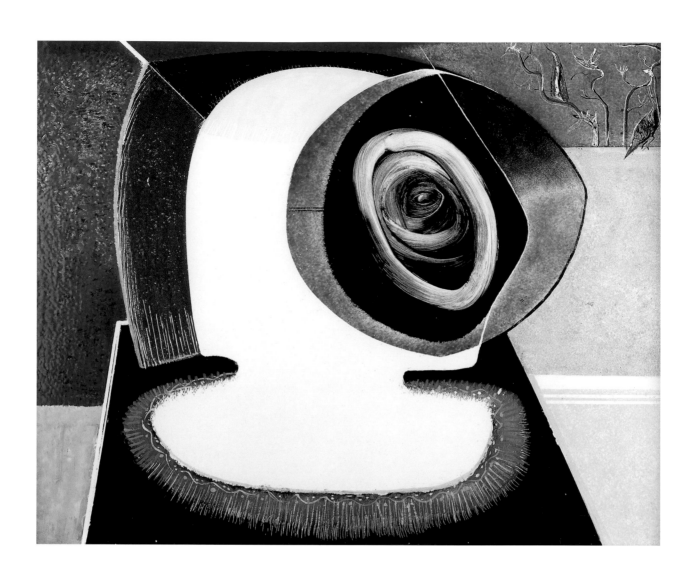

36. Untitled, n.d.
Cat. No. 60

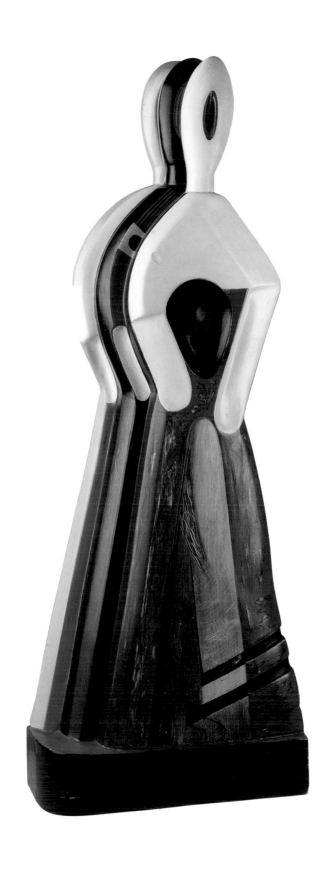

37. *The Four Faces of Man*, n.d.
Cat. No. 58

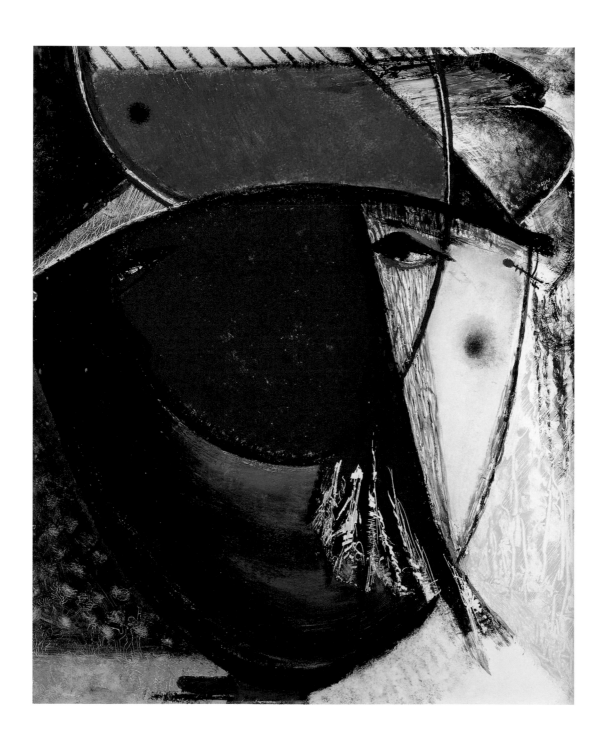

38. *Mask, No. 1, 1966*
Cat. No. 53

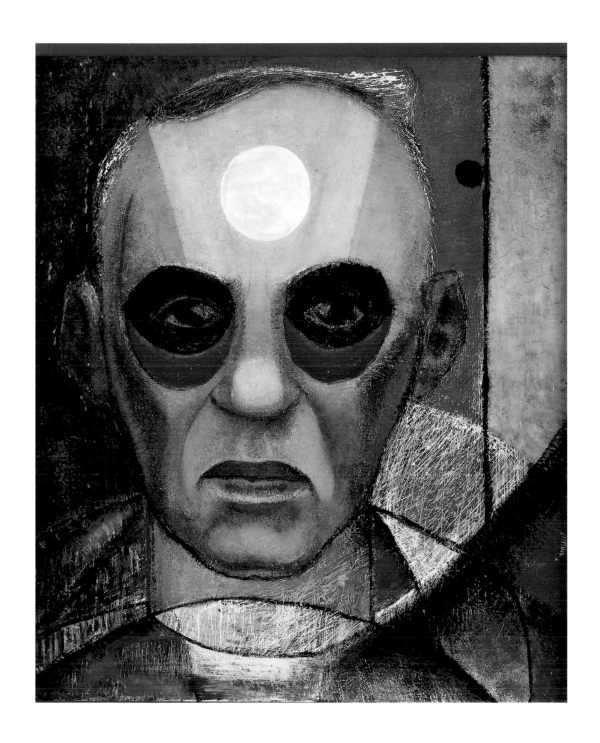

39. Untitled, 1966
Cat. No. 54

Catalogue of Works in the Exhibition

1. *Mask of a Girl,* 1926
 copper repoussé with gilding
 9 x 6 x 2¹/₂ in. (22.9 x 15.2 x 6.4 cm)
 Collection of the Newark Museum,
 Purchase 1992 with funds provided
 by Reba and Dave Williams
 Plate 4

2. *Elizabeth Gee,* 1927
 stoneware with glaze
 13¹/₈ x 10³/₄ x 7¹/₂ in. (33.3 x 27.3 x 19.1 cm)
 San Francisco Museum of Modern Art,
 Albert M. Bender Collection,
 gift of Albert M. Bender, 37.3093
 Plate 2

3. Untitled, 1927
 stoneware with glaze
 13 x 7 x 7¹/₂ in. (33 x 17.8 x 19.1 cm)
 Collection of Dr. and Mrs. Edwin C. Gordon
 Plate 1

4. *Portrait of a Girl,* 1928
 conté crayon
 16 x 9³/₄ in. (40.6 x 24.8 cm)
 Aaron Douglas Collection,
 Amistad Research Center

5. *Mask,* ca. 1930–35
 copper and wood
 15¹/₂ x 13¹/₂ x 6 in. (39.4 x 34.3 x 15.3 cm)
 Collection of the National Museum
 of American Art, Smithsonian Institution,
 Gift of International Business Machines
 Corporation
 Plate 3

6. *Chester,* 1931
 terracotta
 8¹/₂ x 5¹/₂ x 7 in. (21.6 x 14 x 17.8 cm)
 San Francisco Museum of Modern Art,
 Albert M. Bender Collection, bequest of
 Albert M. Bender, 41.2978
 Plate 5

7. *Head of a Boy,* ca. 1931
 conté crayon over graphite on paper
 12¹/₈ x 10³/₄ in. (30.8 x 27.3 cm)
 Collection of the Hampton University
 Museum, Hampton, Virginia
 Plate 6

8. *Forever Free,* 1933
 wood with lacquer and cloth
 36 x 11¹/₂ x 9¹/₂ in. (91.4 x 29.2 x 24.1 cm)
 Collection of the San Francisco Museum
 of Modern Art, gift of Mrs. E. D. Lederman,
 52.4695
 Cover; Plate 8

9. *Mask,* 1933
 copper
 10⁷/₈ x 7⁷/₈ x 2³/₈ in. (27.6 x 20 x 6 cm)
 San Francisco Museum of Modern Art,
 Albert M. Bender Collection, gift of Albert M.
 Bender, 35.3436
 Plate 10

10. *Negro Woman,* 1933
terracotta
6 x 5 x 6 in. (15.2 x 12.7 x 15.2 cm)
San Francisco Museum of Modern Art, Albert
M. Bender Collection, bequest
of Albert M. Bender, 41.2979
Plate 9

11. *Standing Woman,* 1934
painted terracotta
15 3/8 x 4 1/2 x 4 in. (39.1 x 11.4 x 10.2 cm)
Collection of the Fine Arts Museums
of San Francisco, lent by the Federal Works
Project/Works Progress Administration
Plate 12

12. *Mask,* ca. 1934
copper with ceramic inlay
12 x 10 1/2 x 2 1/2 in. (30.5 x 26.7 x 6.4 cm)
Collection of Alan Gordon
Plate 11

13. *Divine Love,* 1935
etching
8 x 6 in. (20.3 x 15.2 cm)
Collection of Melvin Holmes
Plate 7

14. *Exalted,* ca. 1935
etching
5 x 3 7/8 in. (12.7 x 9.8 cm)
Aaron Douglas Collection,
Amistad Research Center

15. *Head of a Boy,* ca. 1935
terracotta
10 x 5 x 6 1/4 in. (25.4 x 12.7 x 15.9 cm)
Aaron Douglas Collection,
Amistad Research Center

16. *Head of a Negro Woman,* ca. 1935
terracotta
7 3/8 x 4 1/2 x 5 1/4 in. (18.7 x 11.4 x 13.3 cm)
San Francisco Museum of Modern Art,
Albert M. Bender Collection, gift of Albert M.
Bender, 35.3439
Plate 14

17. *Negro Woman,* ca. 1935
wood with lacquer and cloth
32 x 13 1/2 x 11 3/4 in. (81.3 x 34.3 x 29.8 cm)
San Francisco Museum of Modern Art,
Albert M. Bender Collection, gift of Albert M.
Bender, 36.6207
Figure 5

18. *Telegraph Hill,* ca. 1935
etching
4 x 5 in. (10.2 x 12.7 cm)
Aaron Douglas Collection,
Amistad Research Center

19. *Lenox Avenue,* 1938
lithograph
20 x 16 1/2 in. (50.8 x 41.9 cm)
Collection of the San Francisco African-
American Historical and Cultural Society
Plate 16

20. *Dorothy C.,* ca. 1938
lithograph
11 1/16 x 6 1/8 in. (28.1 x 15.5 cm)
Collection of the Fine Arts Museums
of San Francisco, extended loan from
California State Library
Plate 15

21. Untitled, ca. 1938
graphite and conté crayon on paper
17½ x 14¼ in. (44.5 x 36.2 cm)
Collection of the San Francisco African-
American Historical and Cultural Society

22. *Hippopotamus*, 1939
glazed ceramic
6 x 25 x 8 in. (15.2 x 63.5 x 20.3 cm)
Collection of Charlotte Irvine
Plate 13

23. *Mother and Child*, n.d.
chalk on paper
32½ x 20 in. (82.6 x 50.8 cm)
San Francisco Museum of Modern Art,
Albert M. Bender Collection, gift of Albert M.
Bender, 36.5991

24. *Singing Saints*, 1940
lithograph
12½ x 9¼ in. (31.8 x 23.5 cm)
Collection of the California Afro-American
Museum Foundation
Plate 17

25. *Female Egyptian Head*, ca. 1940
glazed terracotta
4 x 2½ x 4 in. (10.2 x 6.4 x 10.2 cm)
Collection of Melvin Holmes
Plate 19

26. Untitled, ca. 1940
wood
6¼ x 4 x 5 in. (15.9 x 10.2 x 12.7 cm)
Collection of Melvin Holmes

27. *Woman's Head*, ca. 1940
stone
14½ x 7½ x 8 in. (36.8 x 19.1 x 20.3 cm)
San Francisco Museum of Modern Art,
Albert M. Bender Collection, bequest
of Albert M. Bender, 41.2981

28. *Teapot and Two Cups*, 1941
glazed ceramic
teapot: 5¼ x 8½ x 2 in. (13.3 x 21.6 x 5.1 cm)
cups: 2½ x 3 x 2 in. (6.4 x 7.6 x 5.1 cm) each
Collection of Melvin Holmes
Plate 20

29. Untitled, 1941
colored pencil on tracing paper
10¼ x 8⅜ in. (26 x 21.3 cm)
Collection of John Fredericks
Illus. p. 87

30. Untitled, 1941
glazed terracotta
9¼ x 3¼ x 2 in. (23.5 x 8.3 x 5.1 cm)
Collection of Melvin Holmes

31. Untitled (maquette for George Washington
High School Athletic Field frieze), 1941
cement with aggregate material
36¾ x 60 x 3 in. (93.4 x 152.4 x 7.6 cm)
Collection of George Washington High
School, Est. 1936

32. Untitled (study for mural for George
 Washington High School Athletic Field,
 San Francisco), 1942
 graphite on paper
 47¹/₂ x 190 in. overall (120.7 x 482.6 cm)
 Part A: 47¹/₂ x 130 in. (120.7 x 330.2 cm)
 Part B: 47¹/₂ x 60 in. (120.7 x 152.4 cm)
 Collection of the Oakland Museum
 of California, gift of Margery L. Magnani

33. *Primitive Head*, 1945
 Oaxacan clay
 5 x 2¹/₂ x 4 in. (12.7 x 6.4 x 10.2 cm)
 Collection of Elaine Attias
 Plate 21

34. Untitled, 1945
 terracotta
 8 x 3 x 8 in. (20.3 x 7.6 x 20.3 cm)
 Collection of Melvin Holmes

35. Untitled, 1945
 oil on wood
 16¹/₂ x 12 x ¹/₄ in. (41.9 x 30.5 x .6 cm)
 Collection of Melvin Holmes

36. *Cat*, 1947
 glazed terracotta
 15¹/₂ x 6¹/₂ x 4 in. (39.4 x 16.5 x 10.2 cm)
 Collection of Melvin Holmes

37. *Mother and Child*, 1947
 painted terracotta
 15¹/₄ x 11 x 10 in. (38.7 x 27.9 x 25.4 cm)
 Private collection
 Plate 22

38. *By the Seashore*, 1948
 enamel on steel
 16 x 16 in. (40.6 x 40.6 cm)
 Collection of the San Francisco African-
 American Historical and Cultural Society
 Plate 28

39. *The Knot and the Noose*, 1948
 unglazed terracotta
 9 x 17 x 3 in. (22.9 x 43.2 x 7.6 cm)
 Collection of Melvin Holmes
 Plate 25

40. *War*, 1949
 etching
 16⁵/₈ x 10³/₄ in. (42.2 x 27.3 cm)
 Collection of Glen Nance

41. *Dance Hall* (study for San Francisco Housing
 Authority project), ca. 1950
 watercolor
 10¹/₄ x 8 in. (26 x 20.3 cm)
 Collection of Melvin Holmes
 Plate 23

42. *Dance Hall* (study for San Francisco Housing
 Authority project), ca. 1950
 watercolor
 11¹/₂ x 8 in. (29.2 x 20.3 cm)
 Collection of Melvin Holmes
 Plate 24

43. *Moses*, ca. 1950
 Oaxacan clay
 8 x 4 x 2¹/₂ in. (20.3 x 10.2 x 6.4 cm)
 Collection of Melvin Holmes
 Plate 32

44. Untitled, 1956
enamel on steel
17³/4 x 20³/4 in. (45.1 x 52.7 cm)
Collection of Melvin Holmes

45. Untitled, 1957
painted terracotta
6¹/2 x 6¹/2 x 2 in. (16.5 x 16.5 x 5.1 cm)
Collection of Mrs. Gilbert Blockton
Plate 26

46. *The Bull*, ca. 1960
enamel on steel
12 x 15 in. (30.5 x 38.1 cm)
Collection of Dr. and Mrs. Jack D. Gordon
Plate 29

47. *Rape*, ca. 1960
diorite
14 x 19 x 13 in. (35.6 x 48.3 x 33 cm)
Collection of the San Francisco Museum
of Modern Art, gift of Roger Dunham, 92.93
Plates 30 and 31

48. *The Four Sisters*, 1963
enamel on steel
15¹/4 x 18¹/4 in. (38.7 x 46.4 cm)
Collection of the San Francisco African-
American Historical and Cultural Society
Plate 27

49. *Girl with Braids*, 1964
bronze
8³/4 x 2¹/4 x 2 in. (22.2 x 5.7 x 5.1 cm)
Collection of Melvin Holmes
Plate 33

50. *Mother and Child*, 1965
glazed and painted terracotta
18¹/2 x 7¹/8 x 6¹/4 in. (47 x 18.1 x 15.9 cm)
Collection of Dr. and Mrs. Jack D. Gordon
Plate 34

51. *The Politician*, 1965
Oaxacan clay
6 x 6¹/2 x 1¹/2 in. (15.2 x 16.5 x 3.8 cm)
Collection of Dr. and Mrs. Jack D. Gordon
Plate 35

52. *The Walking Man, He's Going Places*, 1965
black clay
11¹/2 x 4¹/2 x 2¹/2 in. (29.2 x 11.4 x 6.4 cm)
Collection of the Oakland Museum of
California, on loan from Matthew Pemberton

53. *Mask, No. 1*, 1966
enamel on steel
17¹/2 x 15¹/2 in. (44.5 x 39.4 cm)
Collection of the San Francisco African-
American Historical and Cultural Society
Plate 38

54. Untitled, 1966
enamel on steel
17 x 15 in. (43.2 x 38.1 cm)
Collection of the San Francisco African-
American Historical and Cultural Society
Plate 39

55. *Singing Saints*, 1966–67
tempera on enameled steel
31¹/2 x 25 in. (80 x 63.5 cm)
Collection of Melvin Holmes
Plate 18

56. *Head of a Boy,* 1967
 enamel on steel
 17³/4 x 15³/4 in. (45.1 x 40 cm)
 Collection of the San Francisco African-American Historical and Cultural Society

57. Untitled, 1967
 enamel on steel
 13¹/2 x 19³/4 in. (34.3 x 50.2 cm)
 Collection of the San Francisco African-American Historical and Cultural Society

58. *The Four Faces of Man,* n.d.
 polychrome wood
 34¹/2 x 12¹/2 x 6¹/2 in. (87.6 x 31.8 x 16.5 cm)
 Collection of Nancy and Roger Boas
 Plate 37

59. *Self-Portrait,* n.d.
 enamel on steel
 13¹/2 x 17³/4 in. (34.3 x 45.1 cm)
 Collection of The University of Arizona Museum of Art, Museum Purchase with funds provided by the Edward J. Gallagher, Jr., Memorial Fund

60. Untitled, n.d.
 enamel on steel
 14³/4 x 17³/4 in. (37.5 x 45.1 cm)
 Collection of the San Francisco African-American Historical and Cultural Society
 Plate 36

61. Untitled, n.d.
 Georgia marble
 15 x 5³/8 x 8 in. (38.1 x 13.7 x 20.3 cm)
 Collection of The University of Arizona Museum of Art, Museum Purchase with funds provided by the Edward J. Gallagher, Jr., Memorial Fund

Chronology

Compiled by Gwendolyn Shaw

1888 November 7, Sargent (Claude) Harrison Johnson is born in Boston, Massachusetts.

1897 Father, Anderson Johnson, dies.

1902 Mother, Eliza Jackson Johnson, dies. Sargent and his five brothers and sisters move to Washington, D.C., to live with their uncle and aunt, William Tecumseh Sherman Jackson and May Howard Jackson, a sculptor.

1915 Johnson moves to San Francisco during the Panama-Pacific International Exposition. Meets and marries Pearl Lawson. Attends A. W. Best School of Art, California Street, San Francisco; studies drawing and painting.

1917 Works as a "fitter" (framer) employed by Schussler Bros. Lives at 2319 Pine Street.

1919 Begins four years of study at the California School of Fine Arts (CSFA). Attends sculpture classes taught by Ralph Stackpole and Beniamino Bufano.

1920 Works as a tinter of photographs for Willard E. Worden.

1921 First-prize award in student competition, CSFA. Begins a ten-year stint as a framer for Valdespino Framers.

1922 First-prize award in student competition, CSFA.

1923 Only child, a daughter, Pearl Adele, is born.

1925 Gold medal for *Pearl* from the San Francisco Art Association (SFAA) at its *Forty-eighth Annual Exhibition*. Establishes studio in backyard of home at 2777 Park Street, Berkeley.

1926 Begins thirteen-year association with the William E. Harmon Foundation of New York.

1928 Otto H. Kahn Prize of $250.00 from the Harmon Foundation for the bust *Sammy*.

1929 Bronze Award in Fine Arts of $100.00 from the Harmon Foundation.

1931 Medal of First Award for *Chester* from the SFAA at its *Fifty-third Annual Exhibition*.

1932 Elected to the SFAA in May.

1933 Robert C. Ogden Prize of $150.00 from the Harmon Foundation awarded for "most outstanding work in exhibit."

1934 Elected to the Council Board of the SFAA.

1935 First prize for *Forever Free* from the SFAA at its *Fifty-fifth Annual Exhibition*. Achievement Award from the Alameda County Branch of the National Association for the Advancement of Colored People (NAACP).

1936 Johnson and his wife, Pearl Lawson, separate. Daughter, Pearl, remains with mother in Oakland. Johnson serves on the sculpture selection and awards juries for the *Fifty-sixth Annual Exhibition of the SFAA*.

1937 Redwood organ screen, commissioned by the California School for the Blind in Berkeley, is installed.

1938 $25.00 Artist Fund Prize for lithograph titled *White and Black* at the *Annual Exhibition of Drawings and Prints of the SFAA*. Chairman of both the sculpture selection and awards juries for the *Fifty-eighth Annual Exhibition of the SFAA*.

1939 Works with the Federal Art Project (FAP) on the Golden Gate International Exposition at Treasure Island. Completes two monumental sculptures of Incas seated on llamas for the Court of Pacifica and three statues symbolizing Industry, Home Life, and Agriculture for the Alameda–Contra Costa Counties Building. Other works for the FAP completed that year include an incised relief on green Vermont slate at the entrance and a mosaic of ceramic tile on the promenade deck of the Maritime Museum in Aquatic Park, San Francisco (a project for which he was named supervisor); and seven animals in cast terrazzo, no longer extant, at the Sunnydale Housing Project Childcare Center, San Francisco.

Forever Free on view as part of the San Francisco Art Association's *Fifty-fifth Annual Exhibition*, the inaugural exhibition of the San Francisco Museum of Art
1935

Sargent Johnson
Untitled
1941
Collection
of John Fredericks
Cat. No. 29

1940 Returns to CSFA for two years. Studies sculpture with Ralph Stackpole. Serves on the sculpture selection and awards juries for the *Sixtieth Annual Exhibition of Painting and Sculpture of the SFAA*. San Francisco Art Commission selects Johnson to replace Beniamino Bufano on the athletic field frieze at George Washington High School.

1944 Receives Abraham Rosenberg Scholarship from the SFAA.

1945 Travels to Mexico on Rosenberg scholarship to study ceramic techniques in Oaxaca and southern Mexico. Visits with David Alfaro Siqueiros in his studio.

1947 Estranged wife, Pearl, is permanently hospitalized. Johnson teaches sculpture class for the summer series at Mills College in Oakland. Begins experimenting with enamel on steel in the shop of the Paine-Mahoney Company. Serves on the sculpture jury for the *Sixty-sixth Annual Exhibition of Painting and Sculpture of the SFAA*. Teaches art classes for the Junior Workshop program of the San Francisco Housing Authority.

1948 Moves from Berkeley to Telegraph Hill in San Francisco, where he resides at 1507 Grant Avenue. Shares studio at same address with John Magnani, a ceramicist, with whom he collaborates on many works. Completes commission of facade panels in enamel on steel for Nathan Dohrmann & Company, Union Square, San Francisco (no longer extant). Chairman of both the sculpture selection and awards juries for the *Sixty-seventh Annual Exhibition of Oil, Tempera, and Sculpture of the SFAA*. Completes commission of a wall panel in mahogany for the Matson Navigation Company's ocean liner, SS *Lurline*.

1949 Completes commission of a wall panel in enamel on steel for the City Hall Chambers in Richmond. Collaborates with Paine-Mahoney Company in the production of a mural for Harold's Club in Reno, Nevada. Travels to Mexico on a second Abraham Rosenberg Scholarship.

1952 *Forever Free* enters the collection of the San Francisco Museum of Art, gift of Mrs. E. D. Lederman, the sister and heir of the original owner, Mr. Leon Liebes.

1956 Completes commission for two wall mosaics for the Matson Navigation Company's ocean liner, SS *Monterey*.

1958 Travels to Japan.

1964 Johnson's wife, Pearl, dies at Stockton State Hospital.

1965 Johnson moves to a small downtown hotel room.

1967 Sargent Claude Johnson dies, October 10, from a heart attack.

Selected Exhibitions

Compiled by Gwendolyn Shaw

Includes exhibition catalogues and pamplets. These are not repeated in the bibliography.

1925 *Forty-eighth Annual Exhibition of the San Francisco Art Association* (catalogue).

1928 *Exhibit of Fine Arts: Productions of American Negro Artists.* Harmon Foundation and the Commission on the Church and Race Relations, Federal Council of Churches, International House, New York (pamphlet).

1929 *Fifty-first Annual Exhibition.* San Francisco Art Association, San Francisco School of Fine Arts (pamphlet).

 Exhibit of Fine Arts by American Negro Artists. Harmon Foundation, New York (pamphlet).

1930 *Exhibition of Fine Arts by American Negro Artists.* Harmon Foundation and the Commission on the Church and Race Relations, Federal Council of Churches, International House, New York (pamphlet).

1931 *Exhibition of the Work of Negro Artists.* Harmon Foundation at the Art Center, New York (catalogue by Alain Locke et al.).

 Fifty-third Annual Exhibition of the San Francisco Art Association. Palace of the Legion of Honor (pamphlet).

1933 *Exhibition of Productions by Negro Artists.* Harmon Foundation Incorporated, in cooperation with the National Alliance of Art and Industry, Art Center, New York (pamphlet by Alain Locke et al.).

1935 *Negro Artists: An Illustrated Review of Their Achievements, Including Exhibition of Paintings by the Late Malvin Gray Johnson and Sculptures by Richmond Barthé and Sargent Johnson.* Harmon Foundation in cooperation with the Delphic Studios, New York (pamphlet).

 Opening of the San Francisco Museum of Art, with the Fifty-fifth Annual Exhibition of the San Francisco Art Association. . . . San Francisco Museum of Art (pamphlet by Grace L. McCann Morley).

1936 *Fifty-sixth Annual Exhibition of the San Francisco Art Association.* San Francisco Museum of Art (pamphlet by Grace L. McCann Morley).

1938 *Annual Exhibition of Drawings and Prints of the San Francisco Art Association.* San Francisco Museum of Art (pamphlet by Grace L. McCann Morley).

1939 *Frontiers of American Art.* Works Progress Administration, Federal Art Project, M. H. de Young Memorial Museum (catalogue).

 Golden Gate International Exposition (catalogue by Eugen Neuhaus: *The Art of Treasure Island . . .* [Berkeley: University of California Press]).

1940 *California Art Today.* Palace of Fine Arts, San Francisco.

The Art of the American Negro, 1851–1940. The American Negro Exposition, Chicago (catalogue).

1945 *The Negro Artist Comes of Age.* Albany Institute of History and Art, Albany, New York (catalogue).

Art of Our Time. San Francisco Museum of Art (catalogue by Grace L. McCann Morley et al.).

1946 *Eleventh National Ceramic Exhibition.* Syracuse Museum of Fine Arts and the Onondaga Pottery Company, Syracuse, New York.

1947 *Contemporary American Ceramics: Selected from the Eleventh National Ceramic Exhibition.* San Francisco Museum of Art (catalogue by Richard F. Bach et al.).

1952 *Seventy-first Annual Exhibition of the San Francisco Art Association.* San Francisco Museum of Art (pamphlet by Grace L. McCann Morley).

1953 *The Seventh Annual Festival: Art in the Open Square.* The San Francisco Art Commission (catalogue).

1959 *Second Annual Outdoor Exhibition.* Eric Locke Galleries, San Francisco.

1965 *The San Francisco Collector.* M. H. de Young Memorial Museum (catalogue).

1967 *The Negro in American Art.* The California Arts Commission and University of California, Los Angeles (catalogue).

1970 *Dimensions of Black.* La Jolla Museum of Art, La Jolla, California (catalogue by Jehanne Teilet).

1971 *Sargent Johnson: Retrospective.* The Oakland Museum (catalogue by Evangeline J. Montgomery).

1976 *New Deal Art: California.* De Saisset Art Gallery and Museum, University of Santa Clara (catalogue by Lydia Modi Vitale et al.).

Two Centuries of Black American Art. Los Angeles County Museum of Art (catalogue by David C. Driskell).

We Came in Style. Sanderson Museum, San Francisco African-American Historical and Cultural Society.

1977 *Sargent Claude Johnson, 1887–1967, Sculptor; Lawrence Ferlinghetti, Poet, Publisher: San Francisco Art Commission Honor Award Show.* San Francisco Art Commission (pamphlet by Evangeline J. Montgomery et al.).

Painting and Sculpture in California: The Modern Era. San Francisco Museum of Modern Art (catalogue).

1985 *Art in Washington and Its Afro-American Presence, 1940–1970.* Washington Project for the Arts, Washington, D.C. (catalogue by Keith Morrison).

 New Deal Art: WPA Works at the University of Kentucky. University of Kentucky Art Museum (catalogue by Harriet W. Fowler).

 The Federal Art Project: American Prints from the 1930s in the Collection of the University of Michigan Museum of Art. The University of Michigan Museum of Art, Ann Arbor (catalogue).

 Richard Dempsey: 1940 and the Sargent Johnson Legacy. Evans-Tibbs Collection, Washington, D.C.

1987 *Harlem Renaissance: Art of Black America.* Studio Museum of Harlem, New York (catalogue).

1989 *Black Printmakers and the WPA.* The Lehman College Art Gallery, City University of New York, Bronx (catalogue by Leslie King Black Hammond).

 Black Art, Ancestral Legacy: The African Impulse in African-American Art. Dallas Museum of Art (catalogue by Alvia J. Wardlaw et al.).

1990 *Against the Odds: African-American Artists and the Harmon Foundation.* The Newark Museum, New Jersey; Gibbes Museum of Art, Charleston, South Carolina; Chicago Cultural Center (catalogue by Gary A. Reynolds and Beryl J. Wright).

1991 *Graphic Excursions—American Prints in Black and White, 1900–1950: Selections from the Collection of Reba and David Williams.* The American Federation of Arts, Washington, D.C. (catalogue by Karen F. Beall and David W. Kiehl).

1992 *Free within Ourselves: African-American Artists in the Collection of the National Museum of American Art.* National Museum of American Art, Smithsonian Institution, Washington, D.C. (catalogue by Regina A. Perry).

1993 *Alone in a Crowd: Prints of the 1930s–1940s by African-American Artists from the Collection of Reba and Dave Williams.* The Newark Museum, New Jersey (catalogue by M. Stephen Doherty and Lowery Stokes Sims).

1996 *African-American Art: Twentieth-Century Masterworks, III.* Michael Rosenfeld Gallery, New York (catalogue by Michael R. Gall).

 In the Spirit of Resistance: African-American Modernists and the Mexican Muralist School. The American Federation of Arts, New York (catalogue by Lizzetta LeFalle-Collins and Shifra M. Goldman).

1997 *Rhapsodies in Black: Art of the Harlem Renaissance.* Hayward Gallery, London (catalogue by David A. Bailey and Richard J. Powell).

Selected Bibliography

Compiled by Gwendolyn Shaw

Books

Bearden, Romare, and Harry Henderson. *A History of African-American Artists, from 1792 to the Present.* New York: Pantheon, 1993.

Bergman, Peter M. *The Chronological History of the Negro in America.* New York: Harper & Row, 1969.

Brawley, Benjamin Griffith. *The Negro Genius: A New Appraisal of the Achievement of the American Negro in Literature and the Fine Arts.* New York: Biblo & Tannen, 1965.

Cederholm, Theresa Dickason. *Afro-American Artists: A Bio-Bibliographical Directory.* Boston: Trustees of the Boston Public Library, 1973.

Davis, Lenwood G., and Janet L. Sims. *Black Artists in the United States: An Annotated Bibliography of Books, Articles, and Dissertations on Black Artists, 1779–1979.* Westport, Conn.: Greenwood Press, 1980.

Dover, Cedric. *American Negro Art.* Greenwich, Conn.: New York Graphic Society, 1960.

Gebhard, David. *The Architectural/Historical Aspects of the California School for the Blind and California School for the Deaf, Berkeley (1867–1979).* Berkeley: The Regents of the University of California, 1979.

Guzman, Jessie P. *Negro Yearbook.* Tuskeegee, Ala.: Department of Records and Research, Tuskeegee Institute, 1952.

Igoe, Lynn. *250 Years of African American Art: An Annotated Bibliography.* New York: Bowker Press, 1981.

Hopkins, Henry T., et al. *San Francisco Museum of Modern Art: Painting and Sculpture Collection.* San Francisco: San Francisco Museum of Modern Art, 1985.

Lane, John R., et al. *The Making of a Modern Museum: San Francisco Museum of Modern Art.* San Francisco: San Francisco Museum of Modern Art, 1994.

Lewis, Samella. *Art: African American.* New York: Harcourt Brace Jovanovich, 1978.

_____. *African American Art and Artists.* Berkeley and Los Angeles: University of California Press, 1990.

Locke, Alain LeRoy. *Negro Art: Past and Present.* 1936. Reprint. Salem, N.H.: Ayer Company Publishers, 1991.

_____. *The Negro in Art: A Pictorial Record of the Negro Artist and of the Negro Theme in Art.* 1940. Reprint. New York: Hacker Art Books, 1979.

Porter, James A. *Modern Negro Art.* New York: Dryden Press, 1943.

Robinson, Wilhelmena. *Historical Negro Biographies.* New York: Publishers Co., 1967.

Schnier, Jacques. *Sculpture in Modern America.* Berkeley: University of California Press, 1948.

Thiel, Yvonne Greer. *Artists and People.* New York: Philosophical Library, 1959.

Williams, Lynn Barstis. *American Printmakers, 1880–1945: An Index to Reproductions and Biocritical Information.* Metuchen, N.J.: Scarecrow Press, 1993.

Magazine Articles

"Art Association Officers for 1936." *San Francisco Art Association Bulletin* 2, no. 8 (January 1936): 5.

Arvey, Verna. "Sargent Johnson." *Opportunity Journal of Negro Life* 17 (July 1939).

"Awards for Fifty-fifth Annual." *San Francisco Art Association Bulletin* 1, no. 11 (March 1935): 2.

"Competitions and Awards." *San Francisco Art Association Bulletin* 18, no. 12 (December 1952): 7.

"Fifty-seven Negro Artists Presented in Fifth Harmon Foundation Exhibit." *Art Digest,* March 1, 1933, p. 18.

Harris, Michael D. "From Double Consciousness to Double Vision: The Africentric Artist." *African Arts* 27 (April 1994): 44–53.

Henderson, Rose. "Negro Art Exhibit." *Southern Workman* 63, no. 7 (July 1934): 217.

Locke, Alain. "The American Negro as Artist." *American Magazine of Art* (September 1931): 210–20.

Montgomery, Evangeline J. "Sargent Johnson." *International Review of African American Art* 6, no. 2 (1985): 4–17.

"Murals and Sculpture at Golden Gate." *Art Digest,* March 15, 1939, pp. 42–43.

"Negro Artists: Their Works Win Top U.S. Honors." *Life Magazine,* July 22, 1946, pp. 62–65.

"Persons and Achievements to Be Remembered in March; Sargent Johnson." *Negro History Bulletin* 2, no. 6 (March 1939): 51–52.

"Prizes and Statistics of Graphic Show." *San Francisco Art Association Bulletin* 5, no. 2 (September 1938): 2.

"Prize Winners in the Fifty-third Annual Exhibition of the San Francisco Art Association." *California Arts and Architecture,* May 1931, p. 12.

Rosenthal, Mildred. "An Exposition in the Making." *San Francisco Art Association Bulletin* 5, no. 5 (December 1938): 1.

"Sargent Johnson Honored." *San Francisco Art Association Bulletin* 2, no. 1 (May 1935): 6.

"Sargent Johnson: We Call Him Ours." *Opera & Concert,* January 1949.

Stackpole, Ralph. "Montgomery Street Gossip." *San Francisco Art Association Bulletin* 1, no. 6 (October 1934): 1.

"The Walls They Left Behind." *San Francisco,* April 1964.

Newspaper Articles (all citations refer to the
San Francisco Chronicle, unless otherwise noted)

Albright, Thomas. "In the Wake of the Art
Festival." October 6, 1977, p. 60.

"Art Commission, WPA Tangle, 'Bufano' Frieze
Causes First-Class Fight." November 14, 1940,
p. 1.

"Artist in Touch with the People." *The People's
World* (San Francisco), February 2, 1950.

"The City; Art Dispute; New Group to View
Frieze." November 20, 1940, p. 12.

"Contemporary Graphics: *Chronicle* Presents
Second Series of Prints." March 17, 1940, p. 8.

"Disputed Frieze: It's Terrible! It Looks Fine, but . . .
Cries Art Commission." November 19, 1940, p. 1.

"Feud over a Frieze; That Sketch Is Approved."
November 27, 1940, p. 7.

Frankenstein, Alfred. "'We Came in Style':
Historic Portraits of Blacks." July 23, 1976, p. 44.

"Honor to Be Given Artist: Sculptor Wins First Prize
with Bust of S.F. Negro Child." February 9, 1928.

Irvin, Tom. "The City; Bufano Controversy."
June 12, 1940, p. 12.

_____. "School Board Approves Substitute for
Bufano." June 26, 1940, p. 14.

"Mural Installed on the New Dohrmann Store."
February 27, 1948, p. 17.

"Negro Sculptor of Berkeley Twice Honored."
January 5, 1930, p. 7.

"Negro Sculptor Receives Prize." March 12,
1933, p. D3.

"Of Disputing about Art." Letter to the editor
from Homer Ansley, San Francisco. November 25,
1940, p. 12.

"San Francisco Artists." October 6, 1935, p. D3.

"Sargent Johnson Wins a Scholarship."
November 30, 1944, p. 9.

"Sculptor at 2 Cadell Place." *The (Berkeley) Post*,
November 6, 1965.

"Sculptor Sargent Johnson Dies." October 12,
1967, p. 36.

"The S.F. Art War; Experts Again View Frieze."
November 23, 1940, p. 9.

"Today's 'Contemporary' Graphic 'Singing
Saints.'" March 18, 1940, p. 25.

Wysinger, Lena M. "News of Activities of Negroes."
Oakland Tribune, September 15, 1940.

Other Sources

Artists' Files, Library, San Francisco Museum
of Modern Art

Sargent Johnson File, The Paul C. Mills Archive of
California Art, The Oakland Museum of California

Sargent Johnson Papers, Library, San Francisco
Art Institute

Lenders to the Exhibition

Amistad Research Center, Tulane University, New Orleans

Elaine Attias

Mrs. Gilbert Blockton

Nancy and Roger Boas

California Afro-American Museum Foundation

Fine Arts Museums of San Francisco

John Fredericks

Alan Gordon

Dr. and Mrs. Edwin C. Gordon

Dr. and Mrs. Jack D. Gordon

Hampton University Museum, Hampton, Virginia

Melvin Holmes

Charlotte Irvine

Glen Nance

National Museum of American Art, Smithsonian Institution, Washington, D.C.

The Newark Museum, Newark, New Jersey

The Oakland Museum of California

Private collection

San Francisco African-American Historical and Cultural Society

San Francisco Museum of Modern Art

The University of Arizona Museum of Art, Tucson

George Washington High School, San Francisco